IMAGES of America
PLYMOUTH LABOR AND LEISURE

A Trade Card, c. 1880. This card, a printer's sample, was created for the Plymouth Cordage Company.

IMAGES of America
PLYMOUTH LABOR AND LEISURE

James W. Baker

ARCADIA

Copyright © 2005 by James W. Baker
ISBN 0-7385-3712-8

First published 2005

Published by Arcadia Publishing,
Charleston SC, Chicago IL, Portsmouth NH, San Francisco CA

Printed in Great Britain

Library of Congress Catalog Card Number: 2004113068

For all general information, contact Arcadia Publishing:
Telephone 843-853-2070
Fax 843-853-0044
E-mail sales@arcadiapublishing.com
For customer service and orders:
Toll-free 1-888-313-2665

Visit us on the Internet at www.arcadiapublishing.com

Dedicated to all those "later Pilgrims" who came seeking liberty, security, and prosperity in Plymouth's mills and industries; and to my immigrant grandfather, James Baker (1851–1930), and my father, Francis Henry Baker (1903–1970), both of whom worked at Plymouth Cordage during their careers.

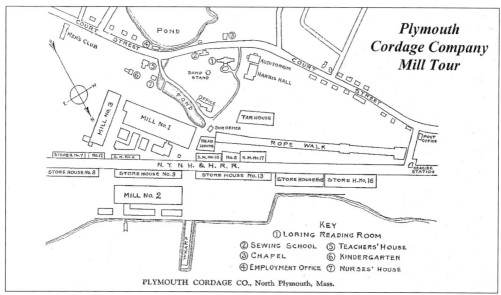

THE PLYMOUTH CORDAGE COMPANY. The buildings of the Plymouth Cordage Company are identified in this diagram.

Contents

Acknowledgments 6

Introduction 7

1. The Plymouth Cordage Company and North Plymouth 11

2. Plymouth's Other Industries 49

3. Plymouth at Leisure 67

Acknowledgments

I would like to once again thank the Pilgrim Society, which provided the greatest number of prints found in this book, and in particular, the director—my loving wife, Peggy M. Baker. The other primary contributor to this collection is the Plymouth Public Library, whose collections of materials relating to Plymouth history and the Plymouth Cordage Company are well represented here. I extend my sincerest thanks to Director Dinah Smith-O'Brien and to Reference Librarians (and local history resource) Lee Regan and Bev Ness. Again, the generosity of the Old Colony Club and of its president, Don Brown, have made it possible to present some images not found elsewhere. I could not have undertaken or completed this book that focuses on the Plymouth Cordage Company without the encouragement and assistance of the Plymouth Cordage Historical Society, and in particular, Bill Rudolph, whose encyclopedic knowledge of the company and its physical plant has proven invaluable. Other members who have significantly guided me in this work are Enzo Monti, Betty Clough, Anna Stefani, Marilyn Neri, Mrs. Louis Bonzagni, Charlie Vandini, and Mary Cash. Finally, I must recognize the liberal and considerable assistance that Helen Hogan and Ken Tavares have given me in rounding out this portrait of Plymouth's significant industrial heritage.

INTRODUCTION

Plymouth, Massachusetts, is a town of many meanings. To the historian, Plymouth signifies the birth of New England as the location of the first permanent European settlement in the region. Similarly, the tourist thinks of Plymouth as "Pilgrimtown," where *Mayflower* passengers were somehow able to step on Plymouth Rock despite its Grecian temple, and then celebrate Thanksgiving, after which Myles Standish lost out to John Alden in wooing the fair maid Priscilla. Outsiders see Plymouth as a quaint yet prosperous Yankee coastal town with miles of picturesque ocean views, acres of wooded parkland, kettle ponds, cranberry bogs, historical attractions (such as Pilgrim Hall and Plimoth Plantation), and plenty of shopping and dining venues. To the homebuyer, it is the state's largest town in area, full of intriguing, old-fashioned homes as well as woodland quickly being suffused with high-quality developments. To the businessman, it is a fast-growing market of potential customers and an excellent site for the location of a new branch or franchise.

It all appears to be a very comfortable blend of the old and the new. To the native Plymouthean, however, the town resembles a kaleidoscope of change. Old landmarks and familiar customs are swept away, and entirely new neighborhoods and developments spring up like mushrooms after an autumn rain. On Long Pond Road—where there was nothing more than a dump, a "piggery" for garbage disposal, and a gravel pit in 1970—there are now the local newspaper offices, a police station, the county prison, and several new commercial developments. The new county courthouse, registry of deeds, and public library will soon all be nearby. The municipal center of gravity appears to have shifted from the neighborhoods pictured in this book to Long Pond Road, in West and South Plymouth.

For the half-century between World War I and the Vietnam War, Plymouth progressed at a much slower pace. The population remained stable at about 15,000 (it is now at 55,000 and rising). Although the mills and businesses that supported the community suffered during the Great Depression and continued to decline after World War II, this happened so gradually that the community's familiar parameters seemed reassuringly durable. Such stability generates an appreciation of heritage and continuity, a personal interest in the stories, landmarks, and characters that were as familiar to one's parents and grandparents as they are to oneself. This was history of a largely personal nature, sustained by the collective memories of each neighborhood, each industry, each family. There may have been more Pilgrim history than could be consumed locally or could be profitably peddled to the eager summer visitors who doubled the population each summer, but the locals cherished the town's more recent history.

The Pilgrims had an honored role in the community, but the average Plymouth family identified more closely with the schools they attended, the stores they shopped in, the mill or factory that paid their wages, and the old, established neighborhoods in which they lived.

This continuity was shattered by changes that began in the mid-1960s. Physically, the community was transformed forever by urban renewal in the downtown residential neighborhood, by the closing of the Plymouth Cordage Company and other local mills, and by the conversion of summer cottage communities into year-round neighborhoods. Plymouth families struggled to find new ways to support themselves after the industrial basis of the local economy declined. The opening of the Pilgrim Nuclear Plant had a dramatic effect on the tax rate, and the completion of the new Route 3 (which bypassed an earlier highway that meandered down Court Street, Main Street, Sandwich Street, Warren Avenue, and State Road) attracted an influx of resident commuters. The year-round population soared, introducing new families with new needs who did not share old town memories. This, of course, occurred at the same time that other cultural forces were struggling to change the American nation as a whole. Like many other communities, old Plymouth was thrust into a new era.

This volume, like its predecessor in Arcadia's Images of America series, presents visual impressions of what the town was like before this significant change took place. The book focuses on the factories and mills, in particular the Plymouth Cordage Company, which dominated Plymouth's economy for many years. "The Cordage," as it was known, was the largest rope manufacturer in the world. Founded by Bourne Spooner in 1824, Plymouth Cordage was a prominent employer that defined the community of North Plymouth. During the 19th and early 20th centuries, the rope company attracted hundreds of immigrant workers—first from Germany, England, and Ireland, and then from Italy and Portugal (especially Cape Verde). The company weathered a great fire in 1885 and a hostile takeover attempt by the Rope Trust in the 1890s, but a more sophisticated buyout in the 1960s finally destroyed the Cordage, which ceased to exist in 1969.

Plymouth Cordage was one of the more genuinely paternalistic mills at the dawn of the 20th century. Under Augustus Loring and Gideon Holmes, the company provided a number of benefits and facilities for its workers, such as the Loring Library, Harris Hall (a large dining and meeting hall), an auditorium, churches, athletic facilities, a kindergarten, community nursing, and pensions. Many employee houses (and land lots for those who wanted to build for themselves) were supplied, and the Cordage organized a band, evening classes, ball teams, social clubs, and events such as employee fairs. However, times changed and the well-meant efforts started to look condescending and authoritarian. In 1916, the Cordage weathered its first major strike. In 1945, by which time the old paternalism was only a memory, the company was unionized. However, the community feeling that the well-intentioned and appreciated amenities engendered survives in the sympathies of former employees and their families, many of whom still live in the Plymouth area.

Plymouth Cordage was the town's largest employer, but it was only one of several mills that sustained Plymouth's economy over a half-century ago. Other important Plymouth industries over the years produced worsted and woolen cloth, tacks, shoes, cotton fabric, insulated wire, ironware, and miscellaneous products, such as rugs, processed clams, and straw hats. The earliest mills had been built on brooks for the waterpower, including Nathan's Brook (North Plymouth), Town Brook, Wellingsley Brook, and Eel River (Chiltonville). Several iron mills and foundries were built on Town Brook before 1800, and a cotton-thread factory and a ropewalk soon followed. The upper branches of Eel River powered mills making sail cloth (Hayden Mill), wooden boxes and window sashes, tacks, woven and rubber hose (Russell Mills), and forges for iron production. Several factories were located on the Plymouth

waterfront (near the local wharves and railway line), such as the Plymouth Woolen Company (later Puritan Mills), George P. Mabbett and Sons (woolen cloth), the Emery Boot and Shoe Company, Edes Manufacturing (zinc and copper products), Ripley and Bartlett (tacks), the Andrew Kerr Company (clam canning), and the Bradley, Ricker Rug Company. Even little Wellingsley Brook supported the Manter and Blackmer hammer mill and the H. M. Ryder carriage factory (which later took up the production of straw hats, and later, toys and games).

The first chapter of this book is dedicated to the Plymouth Cordage Company and the community that it built. The chapter covers the business of Plymouth Cordage (the production of rope and twine) and includes scenes from the lives of managers and workers. Also featured are images of North Plymouth landmarks.

The second chapter covers other Plymouth mills and factories, beginning with the Russell Mills (off Jordan Road in Chiltonville), and other mills on Eel River, Wellingsley Brook, Town Brook, and the Plymouth waterfront. In particular, we look at the Puritan Mills, which occupied the site where the Radisson Hotel is today. The Puritan Mills and Mabbett's Mills (both on Water Street) were second in importance only to the Cordage in the early to mid-20th century.

Of course, life in Plymouth was neither unceasing labor nor inescapable Pilgrim history. In many ways, growing up (or growing old) in Plymouth between 1870 and 1970 was no different than in any other small American town of the time. Plymoutheans shared the popular culture of their eras with other communities across the nation, and were caught up in the revolution in consumption that replaced the unassuming way of life pictured here. Some of the images seen here show us how Plymouth's familiar nooks and corners once looked quite different than they do today.

For many readers, the images in this book will evoke vivid memories of leisure. Even something as mundane as a local grocery store may be later recalled as a significant place where one could smell fresh-ground coffee, buy penny candy (or its equivalent), get truly personalized service, and meet friends. The photographs preserve memories of childhood: summer days of sailing and swimming at a family's favorite pond, skating on that same pond in the winter, or walking to school in the snow.

For other readers, these images will provide evidence of things heard about but never personally experienced. It is to this group that the book is directed—those who never had the privilege to see these scenes in life. For younger residents, visitors, or any student of Plymouth's past, these scenes will help provide a deeper appreciation of the "Old Colony town." Featured in this volume are particular houses, stores, railroads, and electric streetcars, all of which were once familiar but have now vanished, leaving only these shadows behind.

Other shades of the past, such as scenes of farming, fishing schooners, or summer cottage life, stand as representatives of a vanished community. It may be as difficult today to picture Plymouth as a community of fishermen and farmers as it is to imagine it as a mill town, but for 200 years it was just that. These images capture that way of life just as it was about to disappear forever. The age of the summer visitor—that is, those who came to stay for weeks or months at a time in their own "castle," cottage, hotel, or rental property—is perhaps easier to imagine than the fleets and farms. However, although Plymouth is still a major tourist destination, the brief and highly focused motel stay has superseded the relaxed, informal existence of the summer cottage for most Plymouth visitors.

All of these scenes, like the mills and factories, have come and gone, but they need not be lost and forgotten. They are, after all, the fertile past out of which the modern town of Plymouth has grown. In *Plymouth Labor and Leisure*, the personal memories and private history of generations of Plymoutheans are made visible to you. We trust you will enjoy them.

One
THE PLYMOUTH CORDAGE COMPANY AND NORTH PLYMOUTH

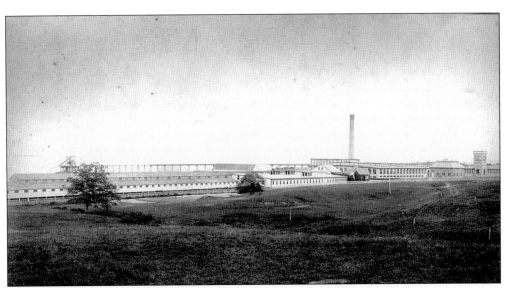

THE OLD ROPEWALK AND PLYMOUTH CORDAGE, C. 1895. This view looks southeast from Court Street near Ropewalk Court.

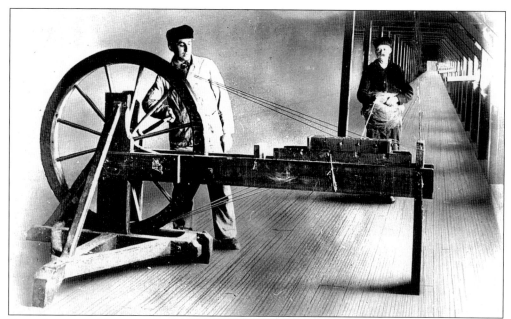

ROPE-SPINNING MACHINERY, C. 1880. Two men show how early rope yarns were made with a spinning mechanism and a man (the spinner), who walked backward down the ropewalk while playing out the fiber wrapped around his waist. The old ropewalk, used until 1945, was 1,050 feet long and could make a rope 100 fathoms long. A large section of this building is now at Old Mystic Seaport in Connecticut.

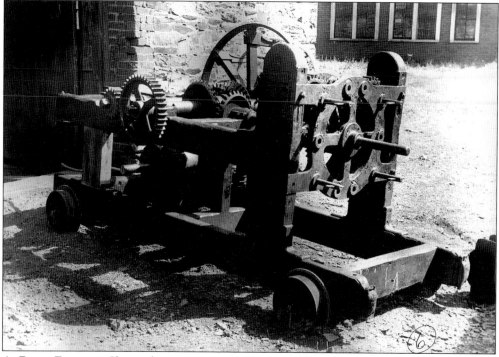

A ROPE FORMER. Shown here is an original piece of equipment used by the Plymouth Cordage Company.

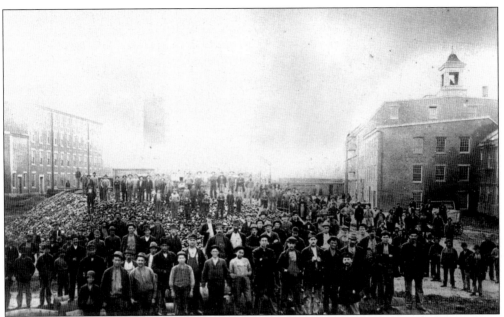

WORKERS AT PLYMOUTH CORDAGE, C. 1882. The men in the foreground are standing on barrels of pine tar used in finishing the cordage. Behind them, a group is standing on a huge heap of coal destined for the mill's first power plant.

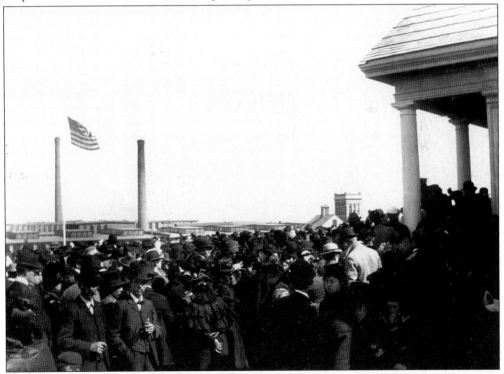

THE PRESENTATION OF THE LORING LIBRARY, OCTOBER 7, 1899. The new library was presented to the company during Plymouth Cordage Company's 75th-anniversary celebration. Dinner that day was served to the employees in the still incomplete Mill No. 2.

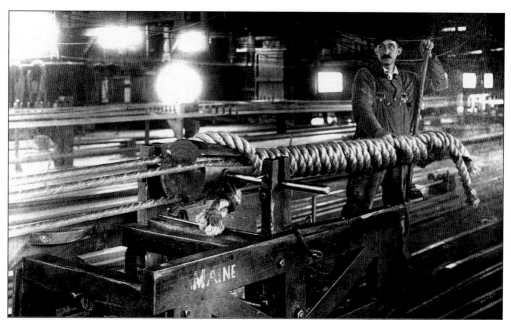

LAYING MEDIUM ROPE, C. 1900. Robert Thom, the foreman, lays three-ply rope the traditional way.

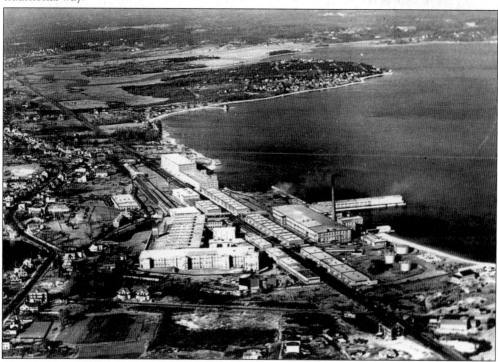

AN AERIAL VIEW OF PLYMOUTH CORDAGE, THE 1940S. In this view to the north, Mill No. 3 is in the center foreground, with Mill No. 1 running north perpendicularly behind it. Mill No. 2 (with a power-plant chimney) is on the right, near the coal pier extending toward the Cordage Channel in Plymouth Harbor. The peninsula to the north is Rocky Nook, in neighboring Kingston, and Duxbury occupies the top of the picture.

WORKERS LEAVING WORK, MILL NO. 2, 1947. The Plymouth Cordage workers seen here include Manuel Rezendes (front left) and Gerald Romano (front right).

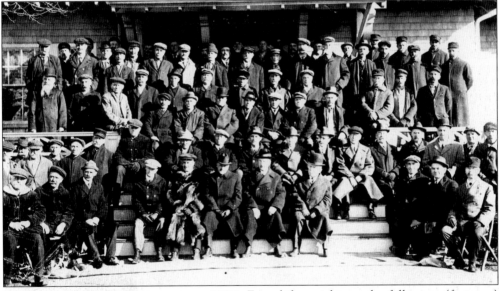

PLYMOUTH CORDAGE EMPLOYEES, C. 1920. From left to right are the following: (first row) Nick Stephen, Bill Wetzel, John Kuhn, Fred A. Hall, Harvey A. Soule, T. Allen Bagnell, F. C. Holmes, Willis Keith, Adam Peck, Phillip Stegmaier, and Axel Frieberg; (second row) Antone Montali, unidentified, George Schied, James Kendrick, Louis Gould, Jacob Stephan, Clinton Hardy, Charles Stegmaier, Frank Kelley, Thomas Swan, R. A. Brown, Richard D. Brown, Henry Stegmaier, Ira C. Ward, Samuel Gray, Nick Casper, Louis Bartz, and unidentified; (third row) David Schreiber, William Cole, Louis Matinzi, Ed Turner, Julius Peck, John Karle, Andrew Voght, unidentified, Manuel Wager, George Bagnell, unidentified, George Kendrick, unidentified, Ed Finney, Dan Morrison, George Freeman, Murray Bosworth, unidentified, and Henry Wirtzburger; (fourth row) Gideon Cash, John Stephan, James Bain, Jacob Sauer, unidentified, Daniel MacDonald, David Edgar, Walter Houghton, unidentified, John Skakle, two unidentified men, William Anderson, Edward Carr, John Youngman, Umberto Gilli, Oliver Holmes, unidentified, Lorenzo Wood, and unidentified. (The men in the back row, in the shadows, are not identified.)

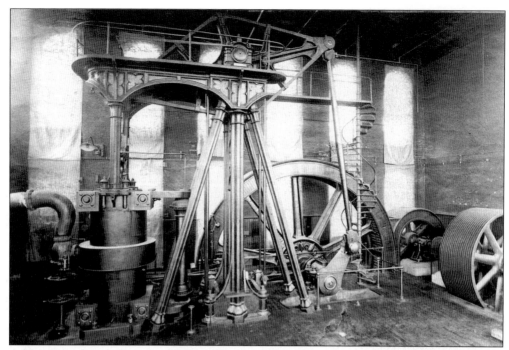

A VERTICAL-BEAM CORLISS ENGINE, EAST OF MILL NO. 1, C. 1885. After the waterpower supplied by Nathan's Brook became insufficient for the needs of the Plymouth Cordage Company, a massive Corliss steam engine was installed in 1867. Located in a small building connected to Mill No. 1, the engine provided power throughout the complex by way of miles of belts, shafts, and pulleys.

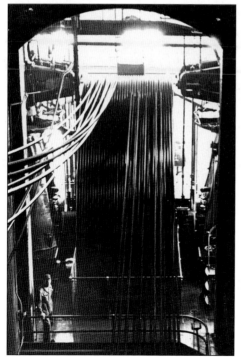

ROPE DRIVES, MILL NO. 2, C. 1940. This 26-foot driving wheel, powered by a Corliss-Dickson steam engine since 1908, supplied power to three floors of the mill that were devoted to the manufacture of binder twine. The photograph was taken by John W. Searles.

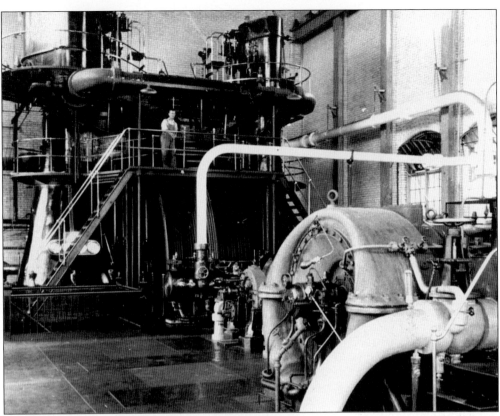
THE ENGINE ROOM, BUILDING NO. 4, 1934. This building was at the east end of Mill No. 2.

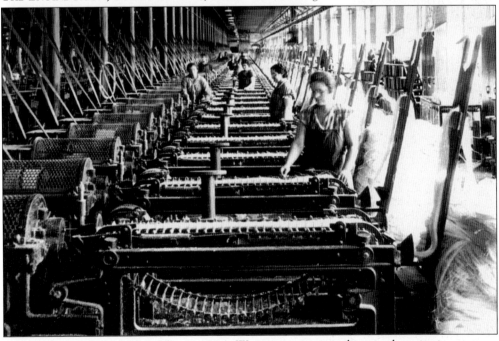
THE SPINNING ROOM, MILL NO. 1, 1934. Women are seen working in the spinning room.

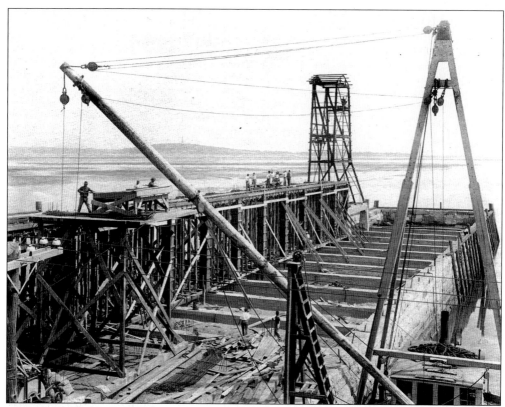

BUILDING THE COAL WHARF, 1912. So much fiber and coal were imported into Plymouth for use at the Plymouth Cordage Company and the other industries that Plymouth collected more customs duties at the time than any other Massachusetts port besides Boston.

DELIVERING FIBER, 1913. The first ship to dock at the new wharf delivers cordage fiber.

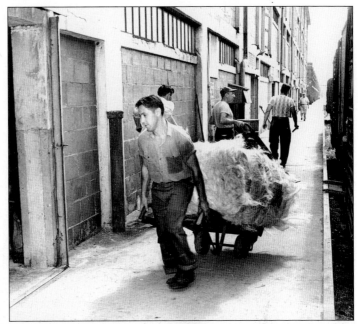

UNLOADING BALES OF FIBER INTO A PLYMOUTH CORDAGE WAREHOUSE, 1949. The Old Colony Railroad, which ran through the Plymouth Cordage grounds, was an important means for delivering supplies of fiber, in addition to the cargoes carried by ship.

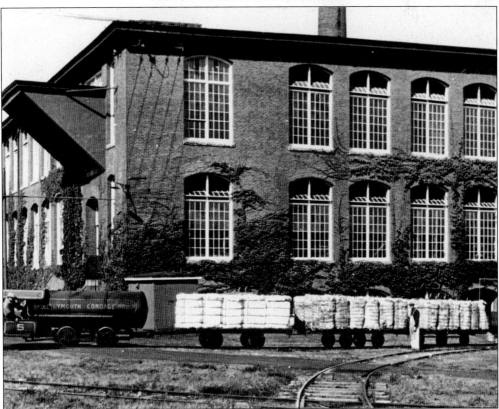

THE COMPRESSED-AIR CORDAGE RAILWAY, 1934. This little internal rail transport, shown delivering bales of fiber to Mill No. 2, connected many of the storage and production buildings at the Plymouth Cordage Company.

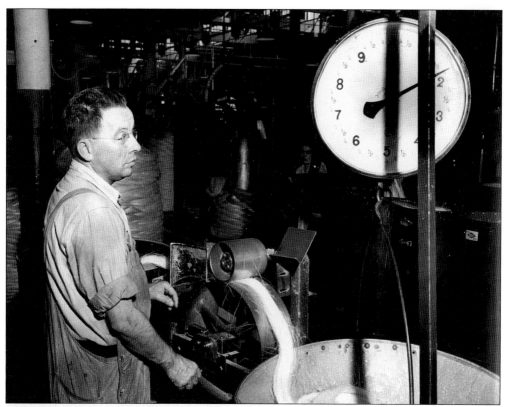

WEIGHING A SLIVER OF FIBER, MILL NO. 1, C. 1950. John Gassman weighs a sample of the fiber to ensure that the spun yarn will be of the desired thickness.

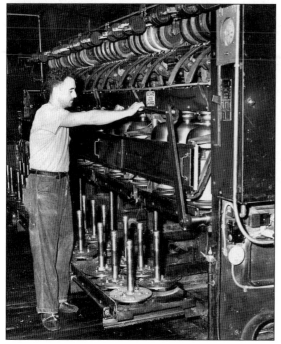

YARN SPUN TO PRODUCE TYING TWINE, MILL NO. 2, THE EARLY 1940s. John Souza operates the spinning jenny.

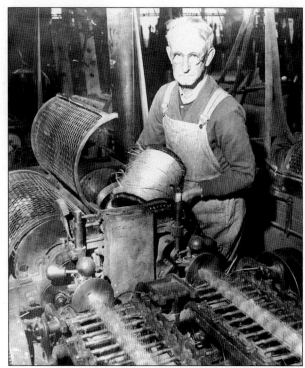

MAKING BINDER TWINE, MILL NO. 2, 1930. Thomas Cash changes the spool on a single-bobbin winder at the Plymouth Cordage Company.

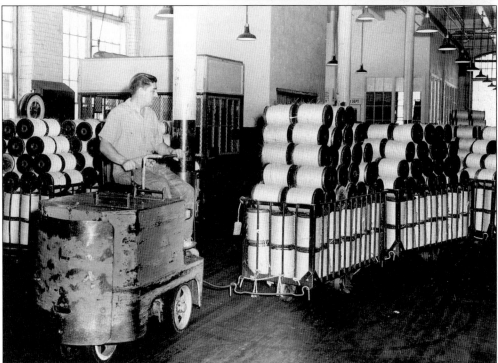

TRANSPORTING SPOOLS OF HARVEST TWINE, MILL NO. 2, SEPTEMBER 29, 1949. Alfred Costa operates the battery-powered tow motor, a predecessor of the forklift, to deliver spools of yarn for processing into twine or rope.

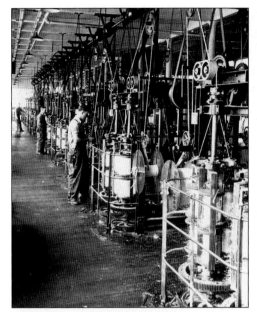 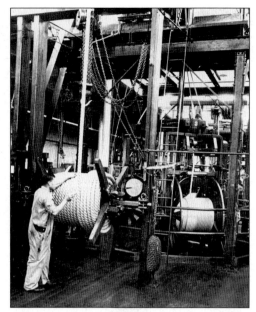

LEFT: THE BAR FRAME, C. 1950. Unidentified workers are shown in Mill No. 1. RIGHT: THE ROPE ROOM, 1934. These two views of rope manufacture in Mill No. 1 (the main mill of the Plymouth Cordage Company) show the machinery for building up cordage from rope yarns to laid stock.

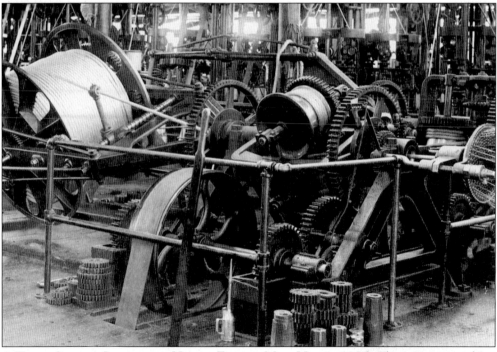

A THREE-STRAND LAYER, THE NORTH END OF MILL NO. 1, 1955. This massive machine combined rope yarns to make three-strand rope up to six inches in diameter for use on ships and other heavy-duty applications. Where most rope today is both synthetic and braided, traditional ropes were made out of natural fibers, such as manila or sisal, and were twisted (laid) together.

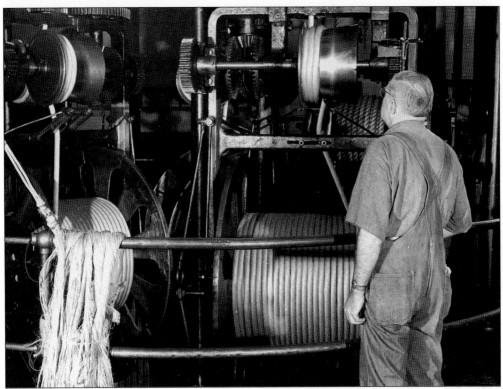

OPERATING THE ROPE MACHINE, THE EARLY 1940s. Walter Carr tends the equipment in the rope room of Mill No. 1.

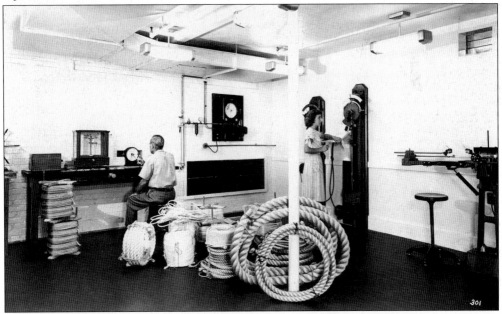

TESTING FIBER WEIGHT AND TENSILE STRENGTH, SEPTEMBER 1948. Raymond Miskelly (left) is at work in the testing lab of the Plymouth Cordage Company to ensure consistent quality and composition of Plymouth rope.

TESTING FIBER, BUILDING NO. 19, C. 1940. The Plymouth Cordage Company was a pioneer in using synthetic fibers in its products.

THE PLYMOUTH CORDAGE LABORATORY, 1934. Stan Cherney (left), John Searles (center), and Harold Mattioli experiment with Plymouth Cordage products.

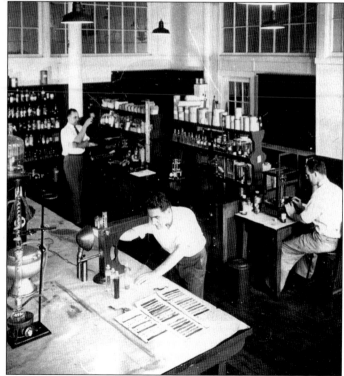

SIMULATING CLIMACTIC AND TEMPERATURE EFFECTS, SEPTEMBER 1948. Rope placed in this machine was subjected to conditions that reproduced the effects of years of moisture and extreme temperatures.

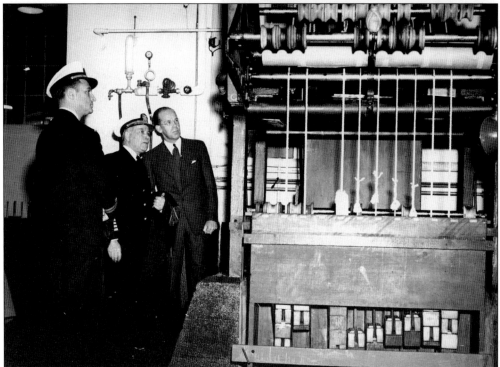

OBSERVING THE TESTING EQUIPMENT, OCTOBER 31, 1944. Raymond Miskelly (right) takes naval officials on a tour of the Plymouth Cordage Company laboratory. The officers were at Plymouth Cordage for ceremonies associated with the wartime Navy "E" Award. The device shown here was used to simulate wear and tear on rope products.

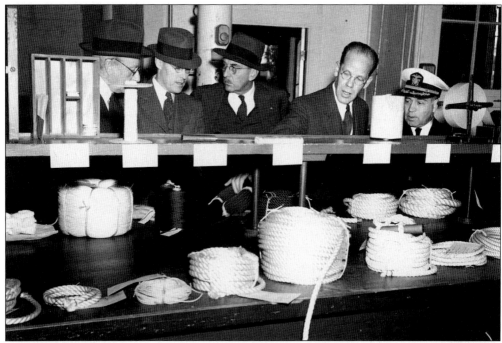

U.S. NAVAL OFFICERS AT PLYMOUTH CORDAGE, OCTOBER 31, 1944. Raymond Miskelly (fourth from left) shows naval officers samples of Plymouth Cordage products.

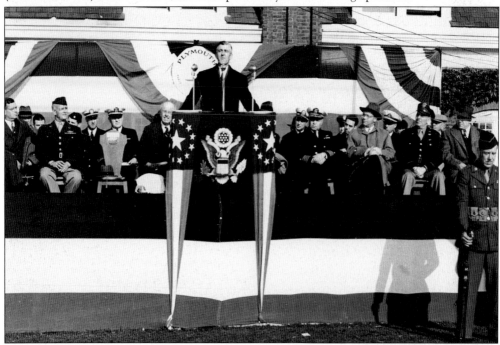

THE NAVY "E" AWARD FOR EXCELLENCE, OCTOBER 31, 1944. The Navy "E" Award was presented to Plymouth Cordage for its wartime contribution. Shown here are Ellis W. Brewster (far left), Joseph Kennedy (third from left), and Sen. Leverett Saltonstall (speaking at the podium).

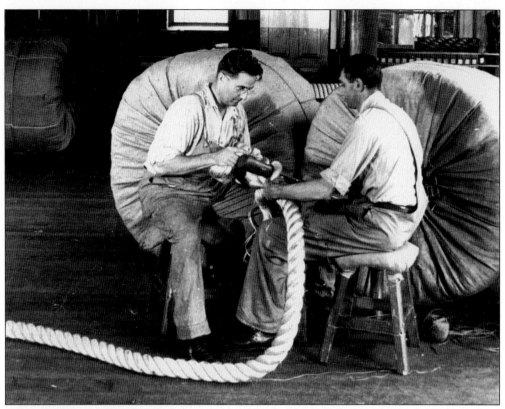

SPLICING ROPE, 1934. Pete Schmidt (left) splices heavy rope with an unidentified coworker.

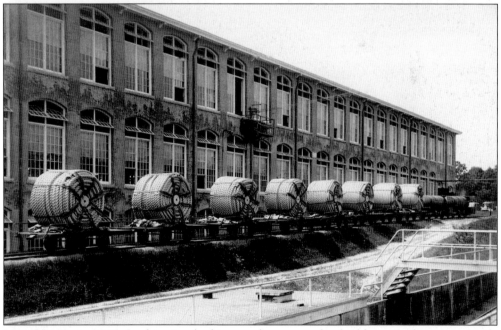

MILL NO. 3, C. 1944. In this view looking southwest, spools of cable await shipment outside the Plymouth Cordage Company's Mill No. 3.

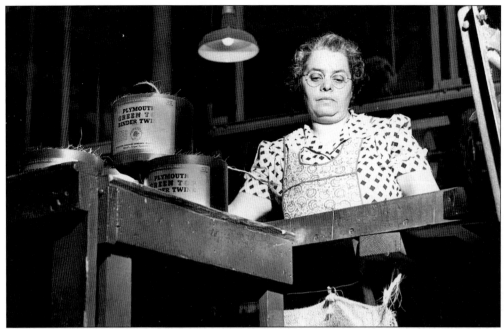

INSPECTING THE "GREEN TOP" BINDER TWINE, 1950. Lucinda Lima checks the balls of harvest twine before they are packed and shipped.

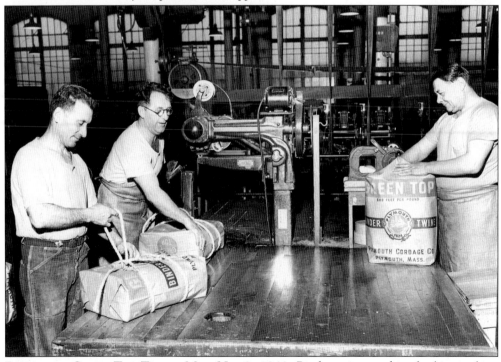

PACKAGING GREEN TOP TWINE, MILL NO. 2, 1940. Binder twine used in the big combine harvesters became a leading product for the Plymouth Cordage Company. By 1921, it made up 40 percent of the company's output in value. Customers also appreciated the short ropes used to wrap the package and complained when rival companies failed to provide similar free lengths.

ROPE FOR SALE, 1940. Plymouth Cordage rope was sold for general use as well as for more specific agricultural, maritime, and industrial applications. One of Plymouth Cordage's most celebrated specialty products was its lariat rope, which was considered the best of its kind. This photograph was taken for publicity purposes.

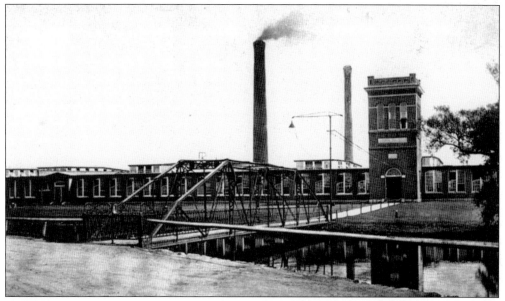

THE BRIDGE ACROSS THE POND, MILL NO. 1, 1906. This bridge was erected in 1885 and was removed in July 1954.

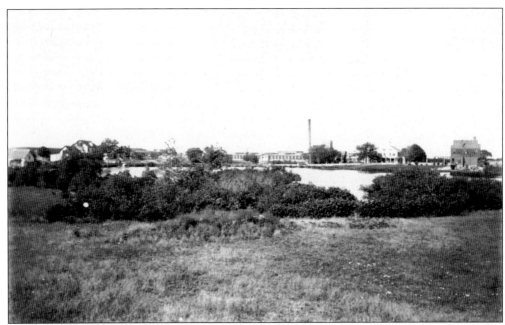

PLYMOUTH CORDAGE BUILDINGS AND SPOONER'S POND, C. 1900. This view, looking northeast from Spooner Street, was taken before the construction of Mill No. 3 and many of the employees' houses.

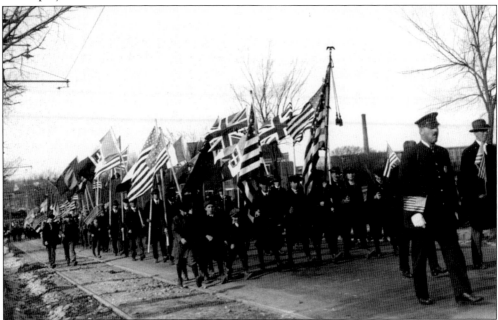

A VICTORY PARADE, NOVEMBER 12, 1918. Seen on Court Street near Cherry Street, the men and boys of Plymouth march in celebration of victory in World War I. The policeman at the front is Joseph Schilling, and John Brewer is on the right. The Color Guard includes, from left to right, Willard Dittmar, George Anderson, Roland Beytes (with the flag), George McLean, and Ralph Pierce. The young boys include, from left to right, an unidentified boy, William McLean, and Lothrop Green.

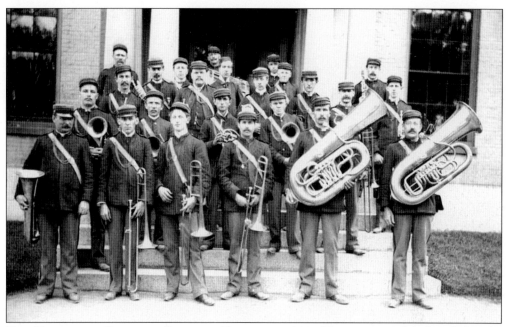

THE PLYMOUTH CORDAGE COMPANY BAND, C. 1900. The company band includes the following: (first row) Edmund Damon (far left), William Armstrong (second from right), and Francis C. Holmes (far right); (second row) John Armstrong (far left) and John Karle (far right); (fourth row) Richard Brown (far left).

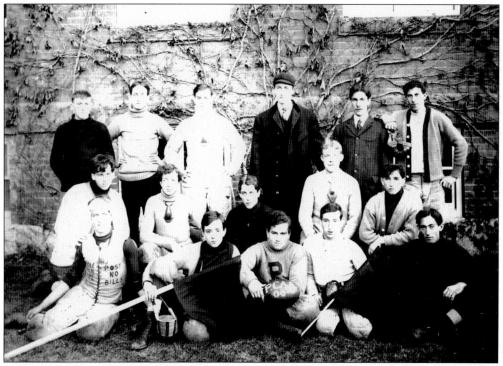

THE FOOTBALL TEAM, 1908. Shown here are the members of the Plymouth Cordage Company Athletic Association football team.

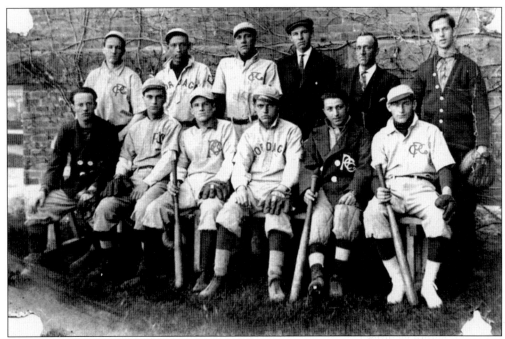

THE PLYMOUTH CORDAGE BASEBALL TEAM, C. 1914. The company baseball team includes, from left to right, the following: (first row) Tony Strassel, Gus Schneider, Arsene Strassel, Carl Yeager, Mando Guidiboni, and Henry Weichel; (second row) Stan Skakele, John Peck, Joe Freyermuth, John Kaiser, George Hertel, and Earl Robichau.

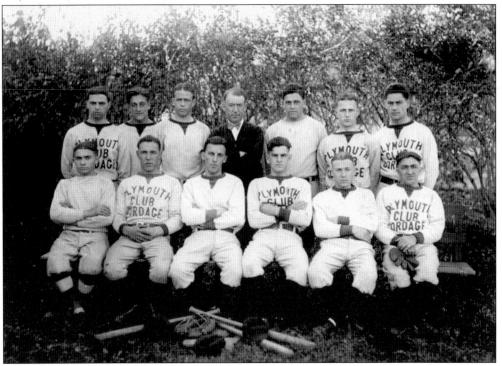

THE PLYMOUTH CORDAGE BASEBALL TEAM, 1927. A later baseball team poses here.

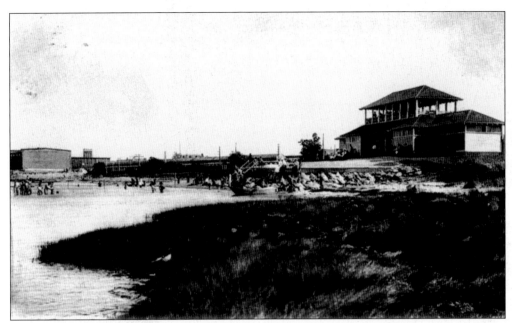

THE PLYMOUTH CORDAGE BATHING FACILITY, 1906. This elegant bathhouse was just one of the several leisure facilities that the company made available to its workers.

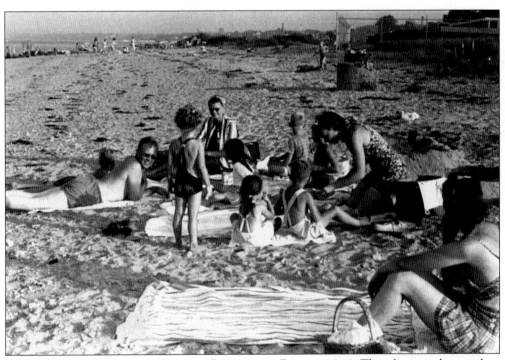

NORTH PLYMOUTH FAMILIES ENJOY A DAY AT THE BEACH, 1949. This photograph was taken below Atlantic Avenue.

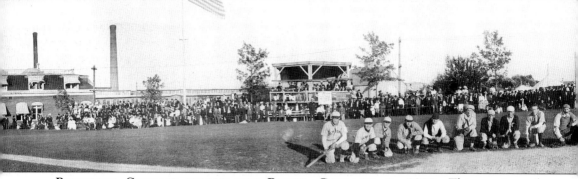

PLYMOUTH CORDAGE VERSUS THE RUSSEL COMPANY, C. 1910. This section of a panoramic view of the playing field—now the parking lot of the Plymouth Wal-Mart—shows the office building to the east (with Mill No. 1 behind it) and the Loring Library to

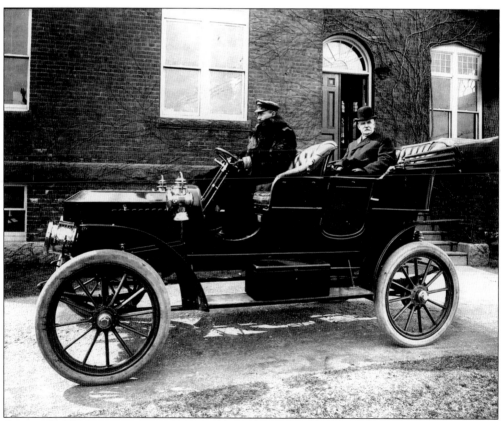

GIDEON F. HOLMES AND HIS CHAUFFEUR, 1909. Gideon F. Holmes (1843–1911) worked his way up the corporate ladder from office boy in 1858 to treasurer in 1882, succeeding the company's founder, Bourne Spooner, in that office.

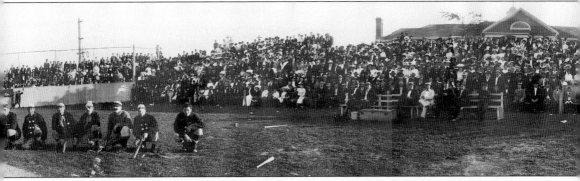

the west in a 180-degree arc. The scoreboard shows that the home team won 4-0 and also announces that there will be moving pictures outside at this location each Friday night.

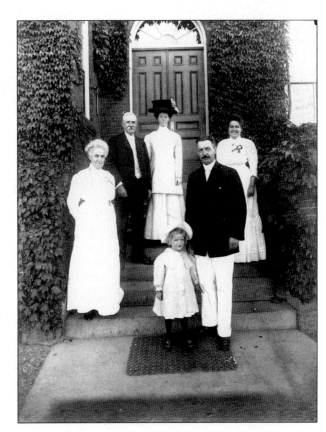

THE GIDEON F. HOLMES FAMILY AT THE MAIN OFFICE, BUILDING NO. 20, 1909. This image of the Holmes family shows, from left to right, Helen Drew (Gideon's wife), Gideon F., Mary Bennett (Francis's wife), Velesta (Francis and Mary's daughter), Francis C. (Gideon's son), and Helen (Gideon's daughter).

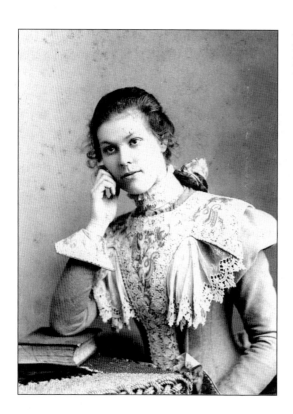

MARY BENNETT HOLMES, C. 1890. Mary Bennett Holmes was the wife of Francis C. Homes.

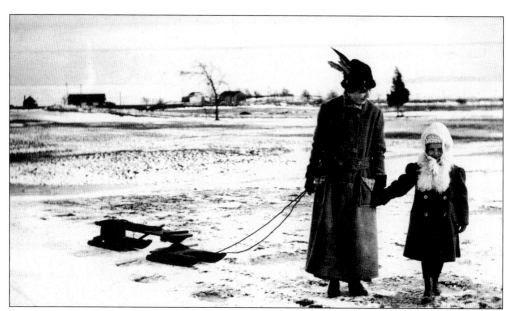

SLEDDING ON HOLMES FIELD, JANUARY 1912. Mary Bennett Holmes and her daughter Velesta are shown near their house, at 264 Court Street in North Plymouth.

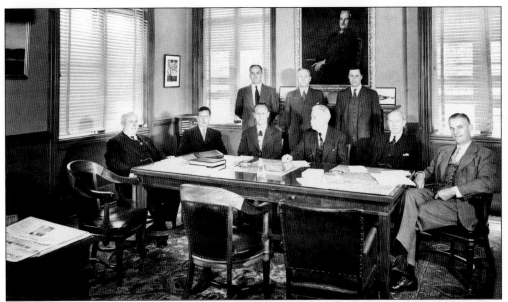

THE PLYMOUTH CORDAGE DIRECTORS, 1949. The company directors are, from left to right, as follows: (seated) Augustus P. Loring Jr., chairman; Ellis W. Brewster, president; Jerome Newman, director; Francis C. Holmes, vice president and director; Caleb Loring, director; and Kenneth Marriner, director; (second row) Charles MacKinnon, clerk and first vice president; Edwin G. Roos, vice president and director; and Augustus P. Loring III, director.

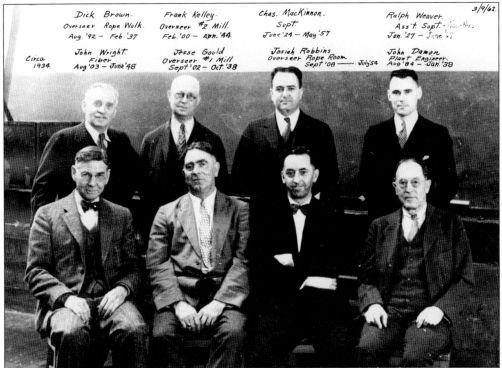

THE PLYMOUTH CORDAGE MANAGERS. This photograph was taken c. 1934; the names and dates of service for the men were added at the top in 1962.

A Plymouth Cordage Worker at Home. In the early 1950s, the Santos family of Kingston was featured in the *Plymouth Cordage News* as an example of the company's ability to provide a good living in the article "John Santos and the American Way." Cordage workers, who once depended on the houses provided by the company, now preferred homes of their own in the Plymouth and Kingston area.

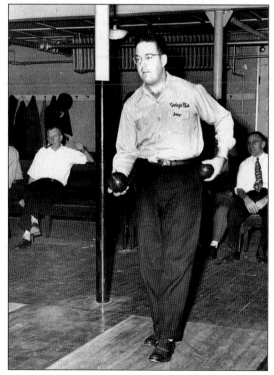

The Plymouth Cordage Bowling Team, the Late 1940s. Jesse Rezendes, who was in the Plymouth Cordage Company's advertising department, appeared in the *Plymouth Cordage News* enjoying candlepin bowling at the Cordage Club on Court Street.

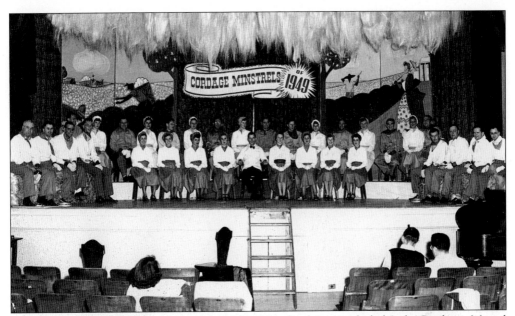

THE CORDAGE MINSTRELS, MAY 25, 1949. Vocal soloists included Lola Guidetti, Muriel Rudolph, Martha Morrison, Stan Remick, and Bruno Zangheri. Instrumental soloists were Joe Vaz (trombone), Jimmie Costa (trumpet), and John Cicero (accordion). The end men were Francis Shea, Antone Ferreira, Desidero "Wack" Zaniboni, Joseph Ledo, Lucien Laurent, Dr. Robert Olson, and Arthur Pedro.

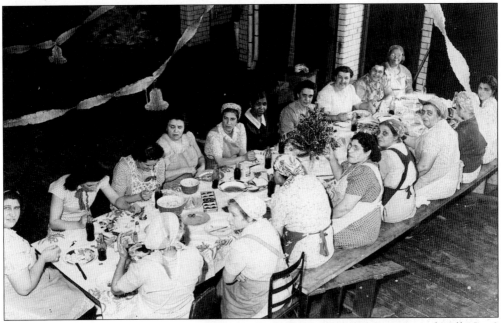

THE PLYMOUTH CORDAGE HOLIDAY PARTY, DECEMBER 1947. The women of Mill No. 3 enjoy a holiday meal. Among the women pictured here are Mary Costa, Mae Carreira, Enis Brevegliari, Kamela Marinos, Isabel Furtado, Martha Andrews, Mary Grave, Hortense Almeida, Georgianna DePrade, Mary Botelho, Sarah Fratus, Annie Cabral, Francesca Correa, Natalie Stanghellini, and Mary Lupo.

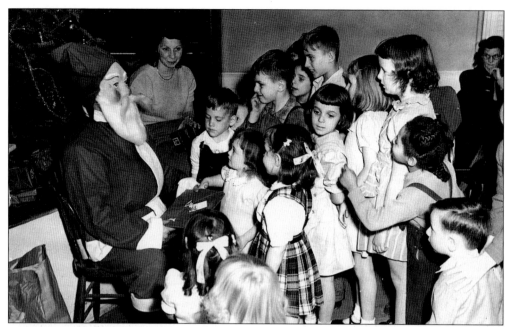

A Children's Party, c. 1950. Santa Claus makes an appearance at a Plymouth Cordage Christmas party.

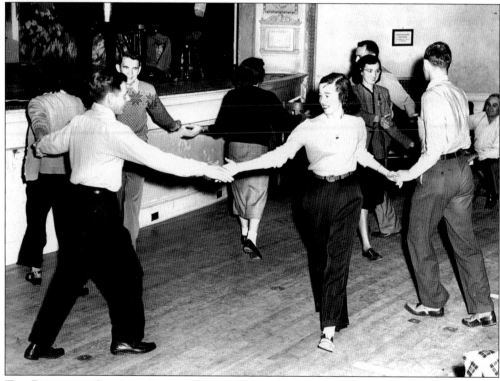

The Plymouth Cordage Dance, Harris Hall, May 1949. Clockwise from the lower left are Dick Taylor, Marion Zaniboni, Tom Reagan, Virginia Mitchell, Stan Remick, Nellie LeCain, Bob Pardee, and Ethel Finney.

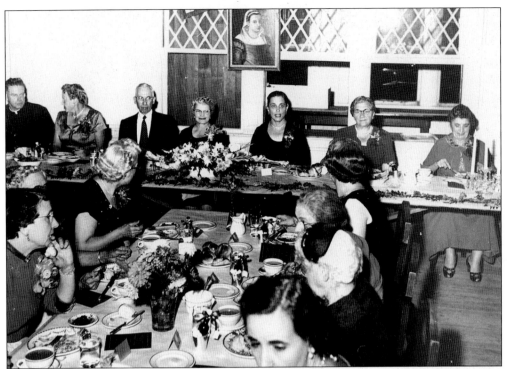

DINNER AT THE VITTORIA COLONNA SOCIETY, HARRIS HALL, THE 1940S. The North Plymouth women's association hosts guests, such as Father Norton (far left) and Judge Amedeo Sgarzi (third from the left). Other attendees include Alice Albertini (far right), Carrie Volta (second from the right), and Wanda Darsch (foreground).

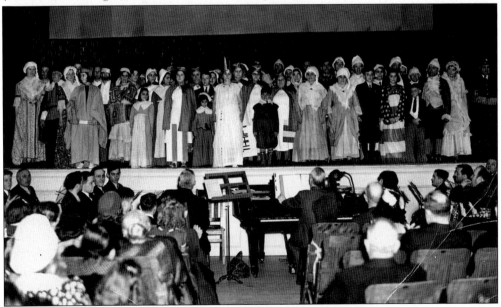

AMERICANIZATION CLASS GRADUATION, 1939. The full range of American history as it was popularly known at the time is represented here by the costumed members of the pageant cast surrounding the graduates in the Plymouth Cordage auditorium.

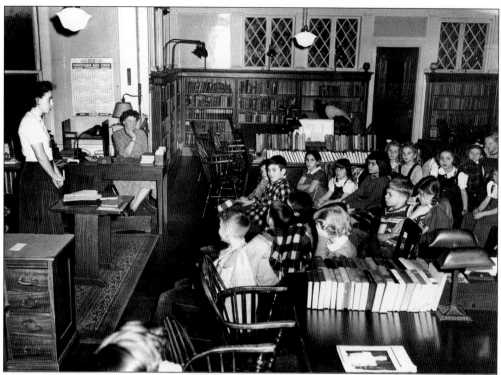

STORY HOUR AT THE LORING LIBRARY, JANUARY 1950. Mrs. August Hunicke (standing) narrates a story to a gathering of local youngsters at the Plymouth Cordage Company's Loring Library, while librarian Minnie B. Figmic (seated left) looks on. Story hours were held on alternate Mondays.

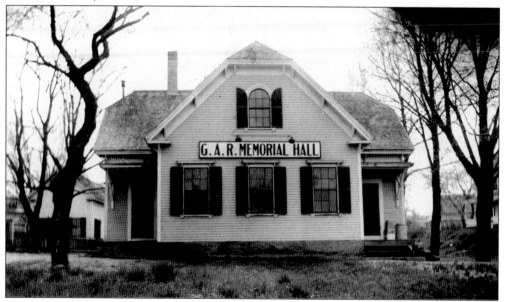

THE ALDEN STREET SCHOOL, MAY 11, 1939. Shown in a view to the north is the Alden Street School (later the Grand Army of the Republic hall). The school was situated close to where 13 Alden Street is today.

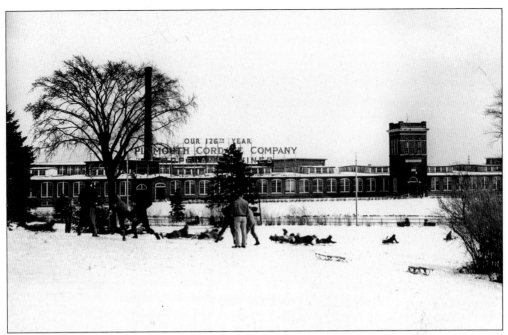

SLEDDING NEAR THE POND, 1950. Sledders are shown across from Plymouth Cordage Mill No. 1.

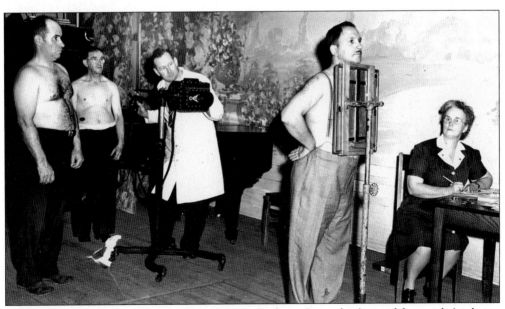

EMPLOYEE X-RAY EXAMINATION, JUNE 1947. Anthony Rezendes (second from right) is being examined for tuberculosis by the doctor.

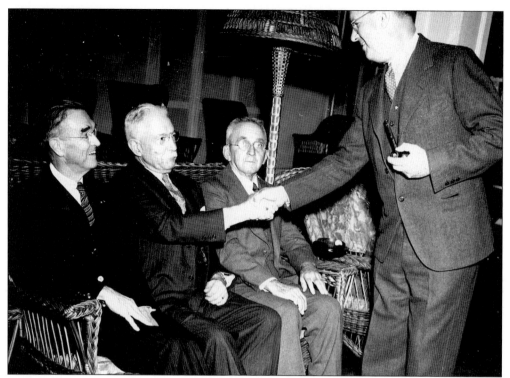

HONORING SENIOR EMPLOYEES, C. 1944. In this view, company president Ellis W. Brewster (standing) congratulates employees. Seated, from left to right, are Fred Hall, Francis C. Holmes, and Lewis Morton.

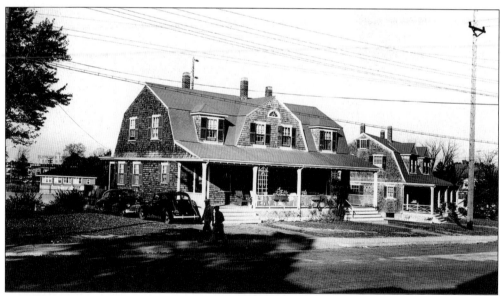

THE HOUSE AT 5 SPOONER STREET, C. 1950. The Plymouth Cordage Company built a number of houses for its employees. This duplex, shown in a view to the east, is an example of the better sort of home that was intended for senior staff members.

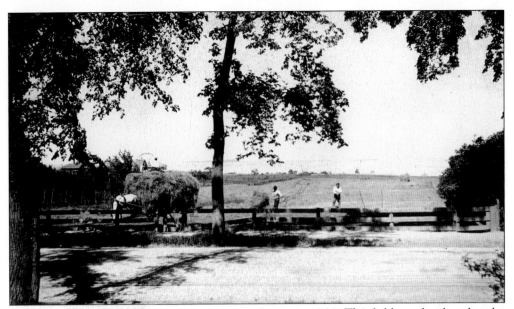

HAYING IN THE PASTURE NORTH OF HOLMES FIELD, C. 1900. This field was developed in the 1960s, but before then there were no houses between Nos. 259 and 271 Court Street. What is now the Holmes Reservation was formerly a muster field for the militia (and, for a short time c. 1905, a golf course) before the Holmes family bought and conserved the land for their North Plymouth neighbors.

JANE DEANS FEEDS HER CHICKENS, SPOONER STREET, THE 1930S. Like many North Plymouth residents, the Deans family raised gardens and fowl to supplement their diet at a time when cordage company wages were low and times were tough.

THE HAWKINS FAMILY, PILGRIM PROGRESS, AUGUST 1932. Velesta Holmes Hawkins (carrying baby Helen Hawkins Hogan) and young Vernon Hawkins prepare for the traditional Plymouth family volunteer participation in the commemorative march from Water Street to Burial Hill.

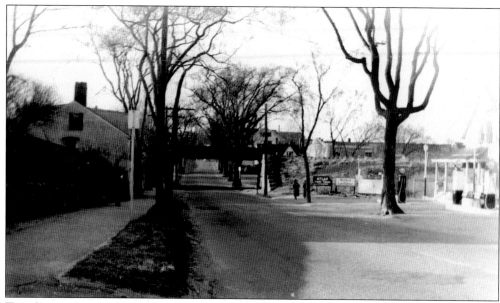

THE COURT STREET RAILROAD BRIDGE, 1938. The Plymouth-to-Middleboro bridge is shown in a view looking north toward Cold Spring. The service station on the right is now Plimoth Glass Company, at 175 Court Street.

THE STANDISH AVENUE RAILROAD BRIDGE, 1938. This view, looking north toward the intersection at Centennial Street (right), shows where the line branched off the Old Colony line near Lothrop Street, and crossed Court Street near the entrance of Standish Plaza. From there the line continued on to West Plymouth (Darby Station), North Carver, East Middleboro, Nemasket, and Middleboro, where the track connected with the Cape Cod line. The ride took about 45 minutes.

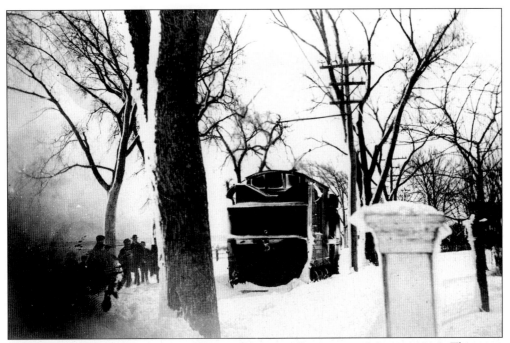

THE BROCKTON AND PLYMOUTH STREET RAILWAY SNOWPLOW, MARCH 1916. This view looks south as the engine clears the tracks opposite Holmes Field. This mechanized snow remover is a great improvement over the earlier practice of manually shoveling snow off Plymouth's streetcar tracks along the main thoroughfare.

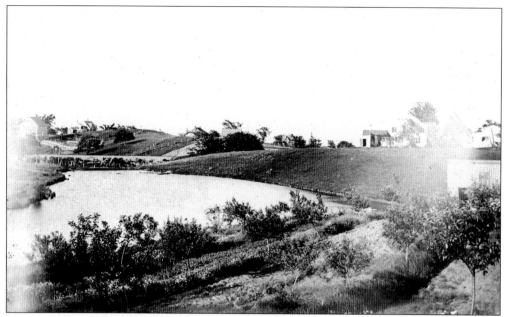

DYER'S POND, NORTH PLYMOUTH, C. 1890. This is a northward view from a point east of Standish Avenue toward the Plymouth and Middleboro Railway line.

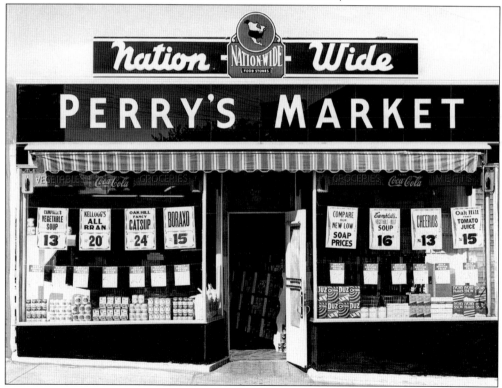

PERRY'S MARKET, 200 STANDISH AVENUE, 1947. A North Plymouth institution, Perry's Market is one of the very few survivors of the neighborhood markets that were once so central to the social and economic life of the town.

Two
Plymouth's Other Industries

THE LEONARD HOMESTEAD, NEAR FORGES POND, CHILTONVILLE, C. 1880. The original iron forges on Double (or Shingle) Brook were built by Nathaniel Leonard, who married into the Joseph Warren family of Plymouth and erected the dam on their estate to carried on a small iron industry c. 1794. The Leonard family had built a famous iron foundry in Norton in the late 17th century.

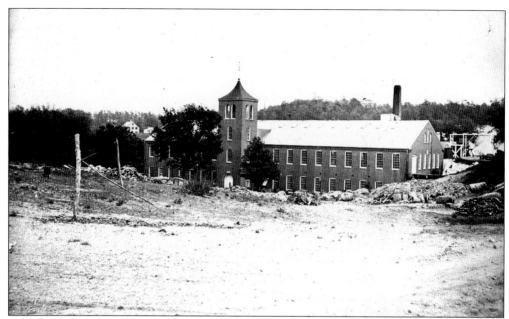

THE COTTON DUCK MILL, C. 1890. This view looks southeast toward Jordan Road. In 1855, the Russell Mills Corporation replaced an earlier ironworks with a new brick mill for the production of cotton products. In 1873, the mill employed 100 people and processed 2,500 pounds of raw cotton each day, using 52 looms, 50 carding machines, and 28 spinners. Southern competition put the Russell Mills cotton duck factory out of business in 1897.

THE BOSTON WOVEN HOSE AND RUBBER COMPANY, RUSSELL MILLS, 1898. Shown here are, from left to right, the pump house, cotton house, duck mill, and barn. The mill was transformed into the Columbia Rubber Company in 1898 by the Boston Woven Hose and Rubber Company, which also acquired the Hayden site as a source of power and operations. The Boston Woven Hose and Rubber operation closed in 1929, and the Russell Mills buildings burned down in 1937.

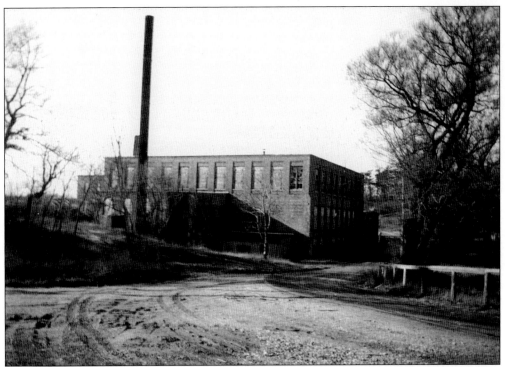

THE BOSTON WOVEN HOSE AND RUBBER MILL, DECEMBER 2, 1933. This view looks north from the corner of Jordan Road and Russell Mills Road.

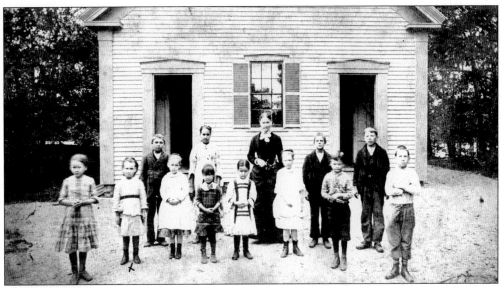

THE RUSSELL MILLS SCHOOL, C. 1900. The school was north of the factory, farther down Russell Mills Road. In this view, teacher Mary A. Morton poses with her class. From left to right are the following: (first row) Katie McDermott, Luella Blanchard, Cora Newhall, unidentified, Lizzie Cameron, two unidentified students, and Ephraim Churchill; (second row) William Grennan, Mary Picard, Mary Morton, Bert Courtney, and ? McDermott.

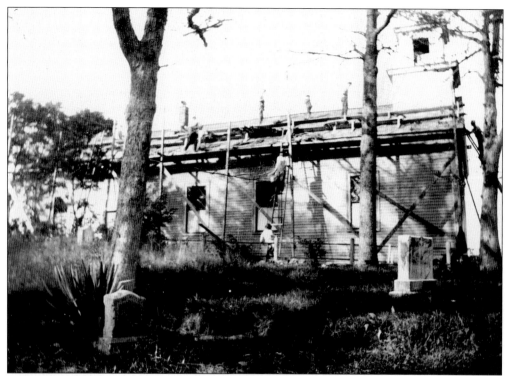

SHINGLING THE RUSSELL MILLS CHAPEL, SEPTEMBER 6, 1919. Like other factory complexes beyond the reach of public transportation, the Russell Mills neighborhood supported its own school and chapel.

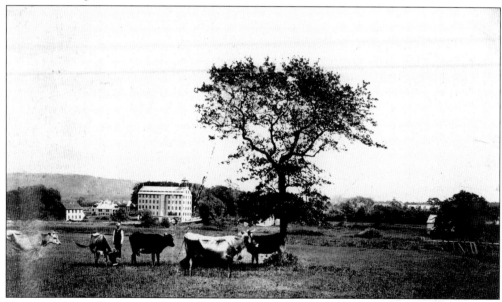

HAYDEN'S MILL, SANDWICH ROAD, CHILTONVILLE, C. 1885. This view looks southeast across the Ellis Farm pasture toward the Pine Hills. There was a cotton-thread mill here as early as 1812. The Plymouth Cotton and Woolen Company made cotton duck (or sailcloth) here from 1844 to 1897, and the structure burned down in 1913.

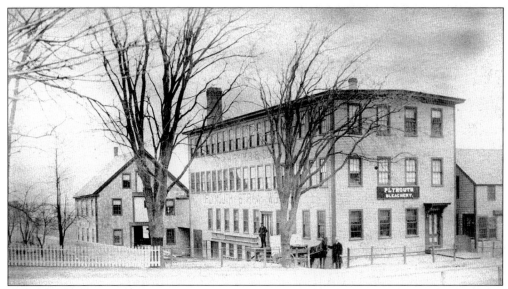

THE PLYMOUTH STRAW HAT COMPANY, SANDWICH STREET, C. 1895. The hat company is seen in a view looking southeast from the corner of Nook Road near Holmes' Point. The manufacture of straw hats was an important New England industry. This factory, earlier employed as a carriage manufactory, was owned by H. M. Ryder. It began operation in 1885 and closed c. 1895. The building housed the Standard Toy and Game Company c. 1905. The structure was razed in the 1930s or 1940s, and there is a small pumping plant here today.

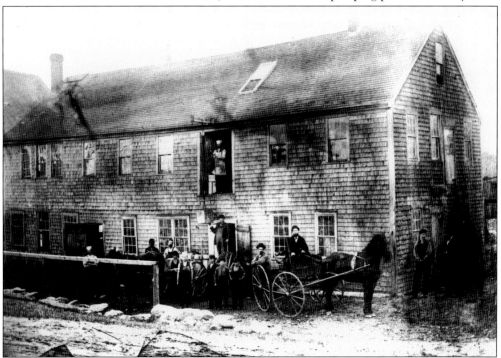

THE MANTER AND BLACKMER HAMMER MILL, HOBS HOLE BROOK, NOOK ROAD, C. 1890. Pictured in a view looking west between Nook Road and Bay View Avenue, this small factory manufactured shoe shanks, hammers, and other ironware until c. 1895.

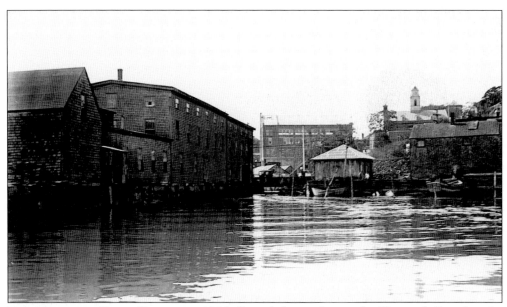

THE MOUTH OF TOWN BROOK, C. 1920. From left to right are the Plymouth Foundry, the Emond Building, the post office, and the Plymouth County Electric Company power plant.

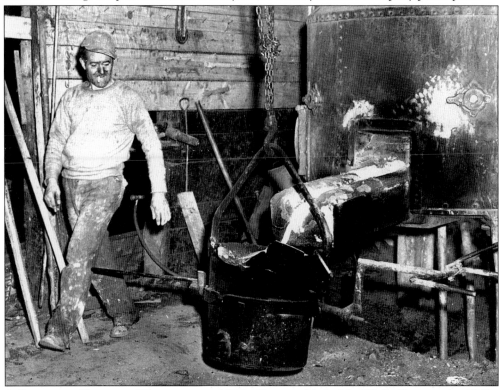

A PLYMOUTH FOUNDRY WORKER, THE 1930S. First established by W. R. Drew in the 1840s, the Plymouth Foundry, located on Water Street, made stoves and hollowware (iron pots and kettles). Eventually, electric stoves and lighter cookware became popular, and the foundry closed down in 1935.

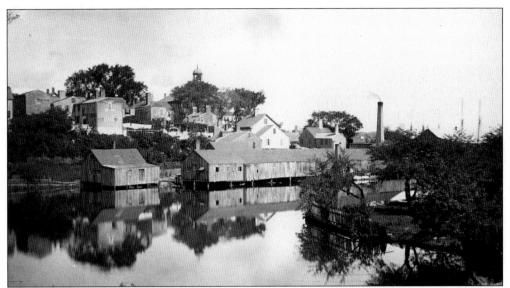

THE E. & J.C. BARNES BOX COMPANY, TOWN BROOK, C. 1890. This view looks north from the foot of the Main Street Extension bridge in Brewster Gardens. The box company occupied a surviving segment of the old Robbins Cordage Company ropewalk. Barnes manufactured both dry (pine) and wet (chestnut and oak) cooperage and wooden boxes for shoes. Ellis Barnes founded the company in 1864, and his brother John C. Barnes continued operations after 1890. The company closed after the introduction of cardboard boxes c. 1914.

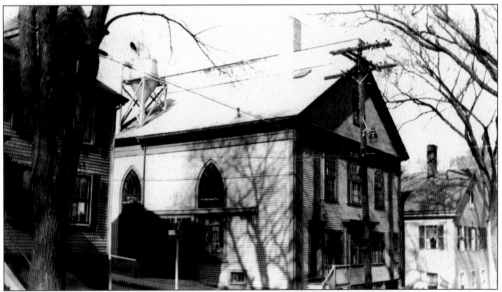

CARROLD HOWLAND'S WORKSHOP, 1938. This building, on the corner of Pleasant and Robinson Streets, was originally the Robinson Congregational Church (1831), an evangelical faction of the Third Church (the Church of the Pilgrimage). The Bradford and Kyle Insulated Wire Company bought the building c. 1885 and used it as a factory until 1905. Howland was an architect, contractor, and builder.

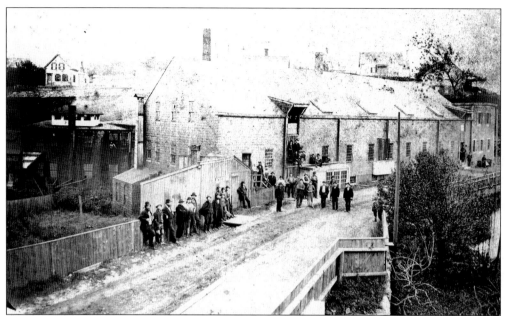

THE LORING AND PARKS TACK FACTORY, POORHOUSE POND, C. 1880. Seen in a view southeastward down Spring Lane, this site is now occupied by the Jenney Grist Mill. Samuel Loring moved his tack factory from Duxbury into what had been part of the Robbins Cordage Company ropewalk c. 1863. His partner, John Parks, enlarged the mill in 1886. It became part of the Atlas Tack Trust in 1891, and was closed down in 1903. Bought by the Bradford and Kyle Insulated Wire Company in 1905, the mill operated until 1966. It was demolished by the redevelopment authority in 1968.

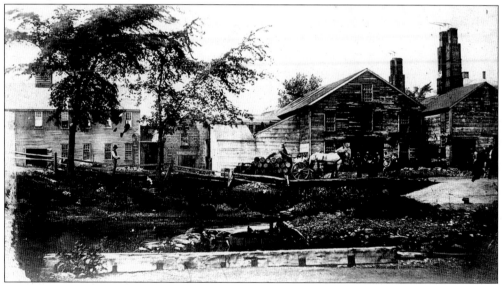

THE ROBINSON IRONWORKS, NEWFIELD STREET, 1876. Begun in 1792 by Martin Brimmer of Boston (who also designed Plymouth's Oak Grove Cemetery), the heirs of Nathaniel Russell sold the ironworks in 1866 to a corporation named after Pilgrim pastor John Robinson. The ironworks ceased operation in 1898, and in 1937, the site became the Samuel W. Holmes Memorial Playground. The man to the left is Willard Wood, and the horses are Shorty and Old White.

THE PLYMOUTH MILLS LOWER WORKS, BILLINGTON STREET, 1940. An ironworks was built on this site in 1800, and it passed through a variety of owners. From 1854 to 1926, the Plymouth Mills manufactured iron and steel products here, including rivets, nails, tacks, and machine parts. Subsequent businesses, such as the Ellis Curtain Company, occupied the buildings before they were destroyed by fire in 1966.

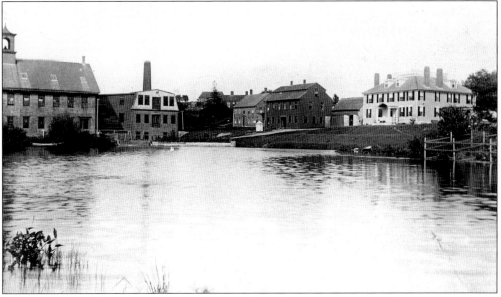

THE STANDISH MILLS, BILLINGTON STREET, 1890. Pictured in a view looking east from Deep Water Bridge, this mill produced cotton cloth beginning in 1812. In 1893 it began manufacturing woolen cloth. The Standish Worsted Company first supported 30 looms, but by 1905, the number had increased to 80. The fine house to the right was built by Solomon Inglee in 1788 near what was then a snuff mill.

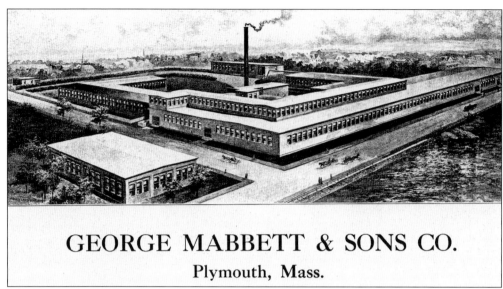

GEORGE P. MABBETT AND SONS, WATER STREET, 1921. The mill (formerly the Plymouth Rock Boot and Shoe Company) was bought by George P. Mabbett and Sons in 1900 and was enlarged in 1907. Mabbett's was bought by Bernard Goldfine in 1952 and closed c. 1964. The surviving building now houses Isaac's Restaurant and other businesses.

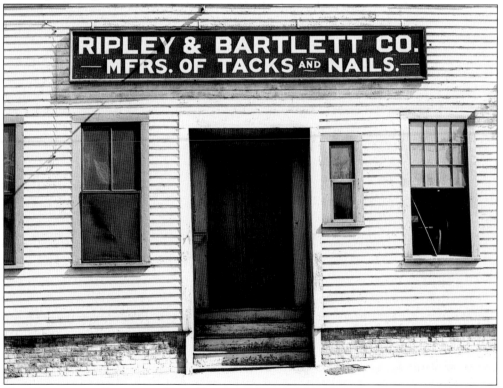

THE RIPLEY AND BARTLETT TACK FACTORY, WATER STREET, C. 1920. Shown in a view looking south from Park Avenue, Ripley and Bartlett's was still in operation in the 1950s. The site is now occupied by Al's Pizza.

THE BRADLEY, RICKER CARPET COMPANY, PARK AVENUE, C. 1920. Pictured in a view to the south, this building now houses the shops Aristocracy and Hillary's, along with the Ming Dynasty restaurant. The Bradley Company was founded c. 1912 and was expanded in 1919. In 1926, the rug company shared its premises with the Gurnet Worsted Company and the Plymouth Yarn Company. In 1939, the site was rebuilt to house the Plymouth Rock Bowling Alleys.

THE EMERY BOOT AND SHOE COMPANY, NORTH PARK AVENUE, C. 1880. This is now the site of the Bridgewater Credit Union and Richard's Wine and Spirits. The massive four-story factory was built for the F. Jones Company in 1873 by the town of Plymouth, on land donated by the Old Colony Railroad. Ownership was transferred in 1875 to Emery, which operated the business until the mill closed in 1899.

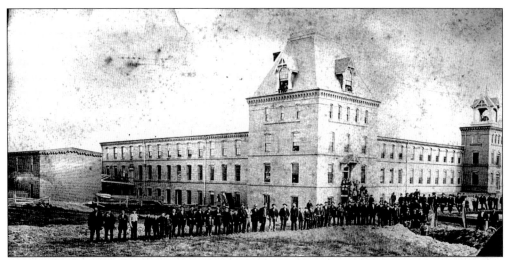

THE DOUGLAS MILL, PLYMOUTH WOOLEN COMPANY, 1880. Seen in a view looking southeast from Murray Street, Plymouth Woolen made mostly flannel suiting cloth. Sold in 1879 to Sawyer and Douglas of Franklin Falls, New Hampshire, the mill was considerably enlarged in 1890. American Woolen Company founder W. W. Wood bought the mill c. 1900, and the business was renamed Puritan Mills.

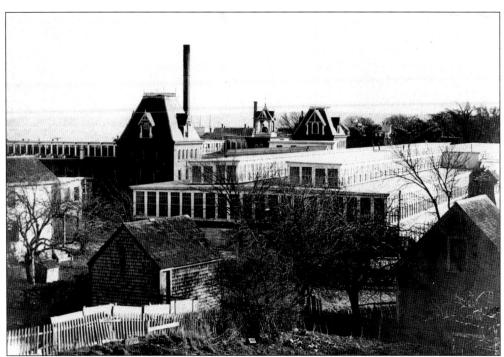

THE PLYMOUTH WOOLEN COMPANY (SOON TO BECOME THE PURITAN MILLS), C. 1890. This view looks southward from Murray Street after the addition of Weave Mill No. 2 to the west of the Main (Douglas) Mill. The site is now occupied by the Plymouth Radisson Hotel.

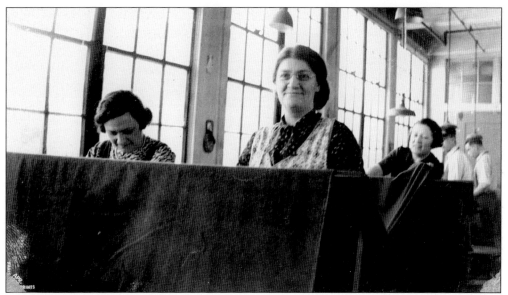

WORKERS FINISH WOOLEN CLOTH IN THE PURITAN MILLS, 1944. These workers inspect the finished woolen fabric, and remove or repair small imperfections. From left to right are Gladys Campana, Mary Peck, Eva Ragazzini, Tony Meurgada, and Tony Viella.

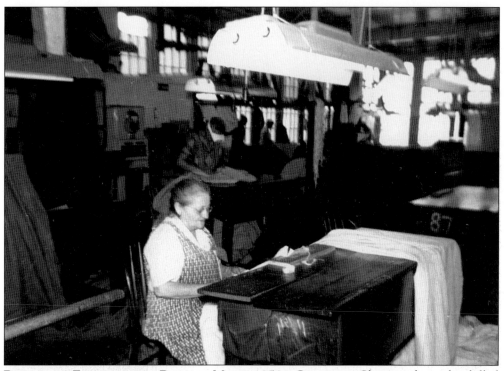

REWEAVING FABRIC AT THE PURITAN MILLS, 1950s. Giuseppina Chiari performs the skilled task of replacing missing threads in the woolen fabric, thus saving the piece of cloth from being rejected or made a second. Chiari was valued enough to retain her position all through the Great Depression, although she only worked two days a week.

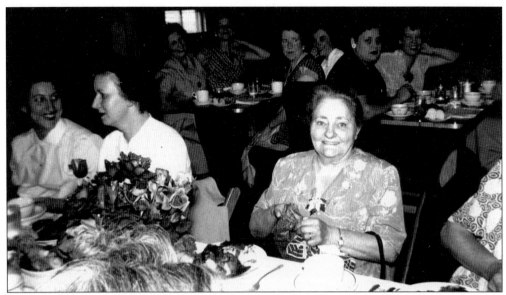

GIUSEPPINA CHIARI (1888–1971) AT HER RETIREMENT PARTY, OCTOBER 1953. Although Giuseppina Chiari worked at the Puritan Mills, her retirement party was held in the Plymouth Cordage Company's Harris Hall.

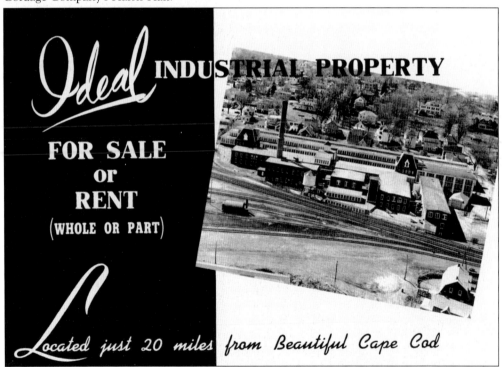

A FLYER FOR THE SALE OF THE PURITAN MILLS, C. 1956. Founded as the Plymouth Woolen Company in 1863, the mill was bought by the American Woolen Company and renamed the Puritan Mills in 1900. It was one of the community's largest employers, after the Plymouth Cordage Company, and its many workers' houses still exist today. The site is now occupied by Village Landing and the Radisson Hotel.

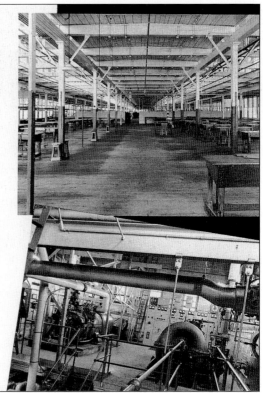

IF YOU ARE *Looking* FOR

AN IDEAL LOCATION

Historical Plymouth offers many advantages to a modern and progressive manufacturing organization. Only forty miles from the heart of Boston and forty five miles from Providence, Rhode Island, it is well outside the congested urban areas. Excellent railroad facilities and a network of express highways offer practical transportation advantages. Located on the ocean, Plymouth not only has one of the most beautiful harbors on the coast, but warm Atlantic waters tend to soften extremes of winter cold, snow and ice.

The Puritan Mill is located within easy reach of adjacent markets, only forty miles from Boston and forty five miles from Providence and a fifteen mile distance from Cape Cod. The building site is on the N.Y.N.H.&H. Railroad and has its own siding for five cars. Plenty of parking facilities and truck platforms make the building easily accessible for all purposes.

A SECTION FROM THE PURITAN MILLS FLYER, C. 1956. This section shows two interior views of this important Plymouth mill.

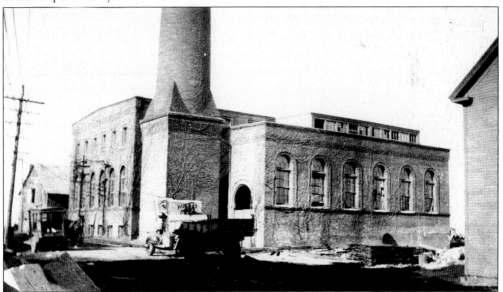

THE BROCKTON AND PLYMOUTH STREET RAILWAY POWER PLANT, C. 1919. The power plant, which provided electricity for the streetcars, is shown in a view to the northeast from the foot of North Street. The building stood on Water Street, near where the entrance to the State Pier is today. The plant was torn down as part of the preparations for the Plymouth tercentenary.

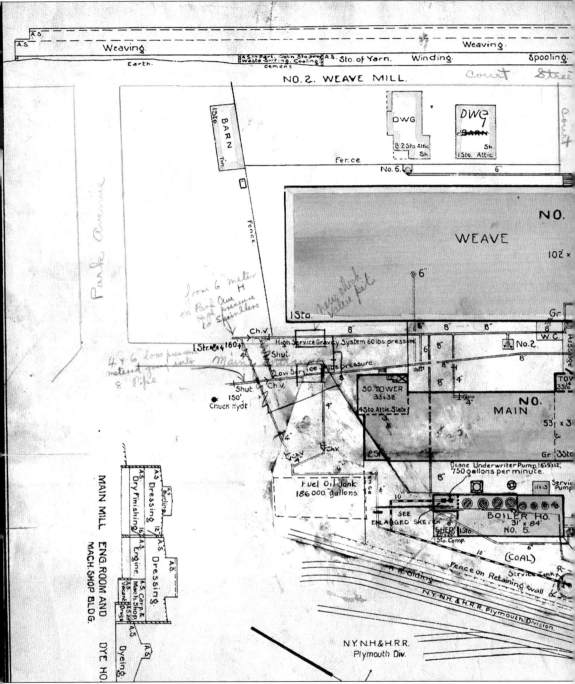

The Floor Plan of the Puritan Mills, c. 1930. Plymouth Woolen Mills was founded in 1863 by Dwight Faulkner. It was located where the Radisson Hotel and its parking lots are today. Plymouth Woolen made mostly flannel suiting cloth during its early years. In 1879, the mill was sold to Sawyer and Douglas of Franklin Falls, New Hampshire. The new owners considerably enlarged the facility in 1890, and c. 1900 sold the mill to W. W. Wood, founder of the new American Woolen Company. The Puritan Mills, as it was then called, prospered

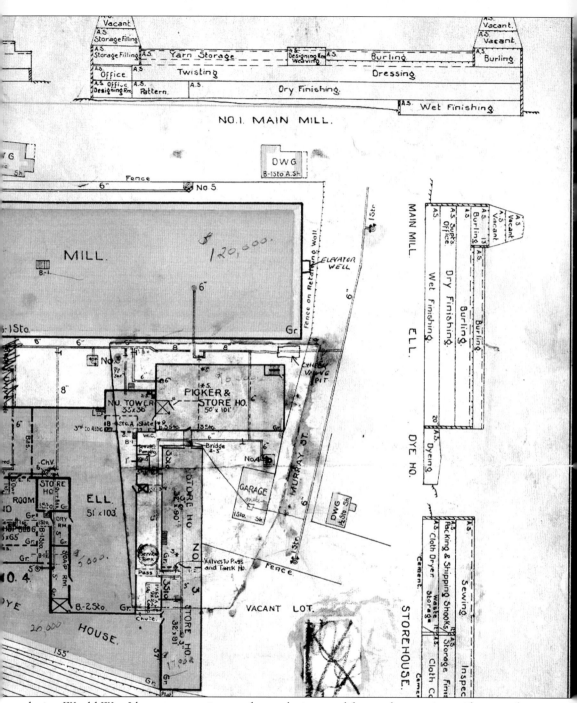

during World War I by concentrating on the explosive need for woolen service uniforms and blankets. The company continued to enjoy a high volume of orders for suiting and flannel into the early 1920s, but then business sharply declined. The mill found itself unable to compete once the government contracts dried up. The Puritan Mills continued to operate in a depressed condition until it closed in 1955.

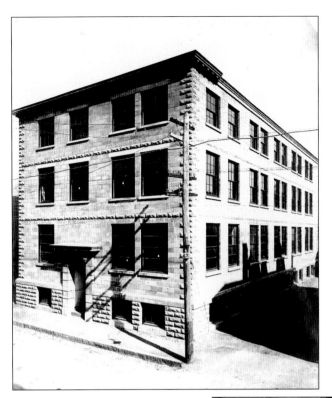

THE OLD COLONY MEMORIAL BUILDING, 23 MIDDLE STREET, C. 1950. This view, looking east, shows the building that housed the offices of the Old Colony Memorial newspaper. The paper was published here from 1904 until the move to Long Pond Road in 1978.

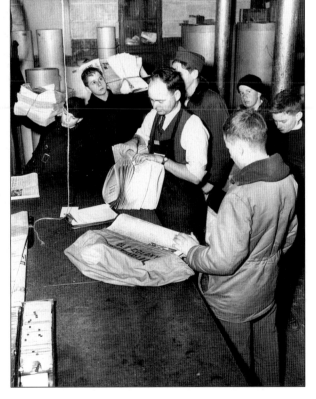

NEWSBOYS AT THE OLD COLONY MEMORIAL BUILDING, C. 1950. Before Old Colony Memorial's move to Long Pond Road, and before mail delivery had begun, Plymouth boys gathered at Middle Street each Thursday at the printing office to pick up papers for their routes. They got to keep a small portion of the 10¢ purchase price.

Three
PLYMOUTH AT LEISURE

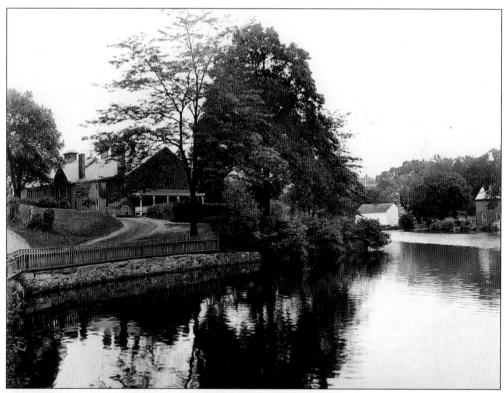

THE PLYMOUTH POOR HOUSE, THE 1890s. Not all leisure was voluntary. The Plymouth Poor House is seen here in a southwest view from the Loring tack factory, now the site of the Jenney Grist Mill. The impressive tulip poplar trees in the center are still in place today.

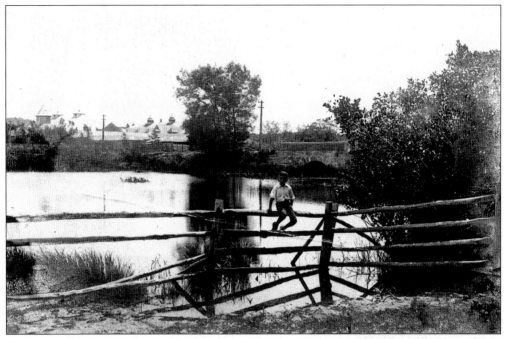

THE OLD SANDWICH ROAD BRIDGE OVER DOUBLE BROOK, C. 1900. This view looks southwest from a point near the Nathaniel Wood and Sons zinc factory, on Jordan Road. Eben Jordan built an elaborate complex of stables and a tanbark training ring along Old Sandwich Road on his summer estate, known as the Forges. The 18th-century forges for which the property was named were located farther south along the brook.

KATE SAMPSON'S SCHOOLHOUSE, CLIFFORD ROAD, c. 1890. Pictured in a view northward from Clifford Road, the school stood opposite the corner of Doten and Clifford Roads.

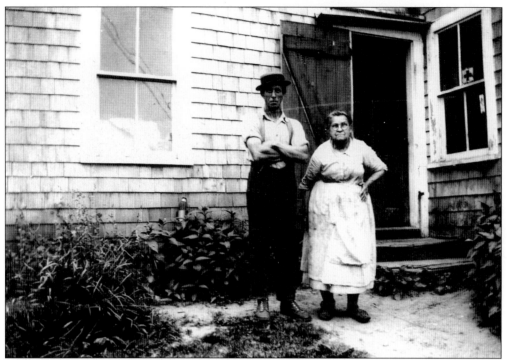

THE FISH FAMILY FARM, NEAR THE RUSSELL MILLS, JULY 1929. The Russell Mills neighborhood was not solely industrial. Just north of the mills were old family farms that carried on their traditional way of life despite the industrial presence down the road. In this image, Alton Fish stands with his mother, Georgietta Fish, at their farm.

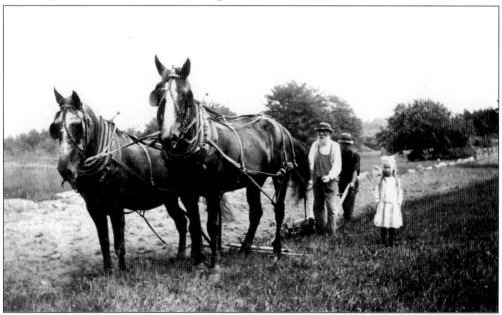

GEORGE FISH WITH HIS TEAM, NEAR THE RUSSELL MILLS, C. 1920. George Fish holds the reins while Herbert Blanchard steers the plough behind him, and young Miriam Blanchard stands nearby. The horses are Kit and Fran.

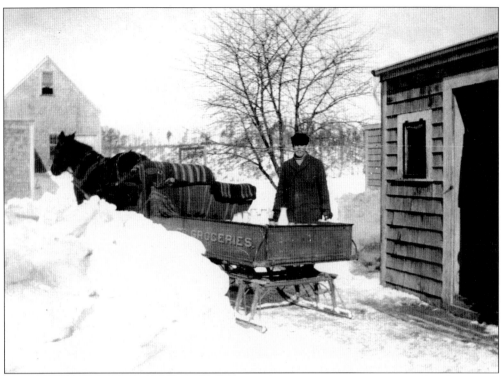

HERBERT BLANCHARD WITH HIS PUNG, 1919. A pung was a wagon equipped with runners for traveling snowy roads. Herbert Blanchard, seen here near the Russell Mills, delivered milk and other supplies to his neighbors.

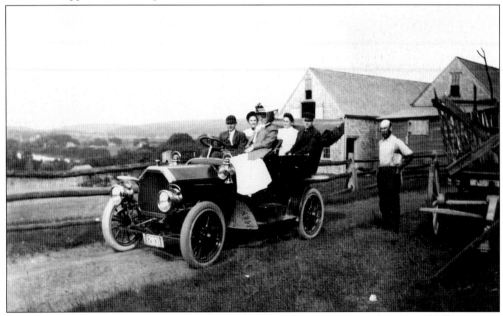

AT BLANCHARD'S FARM, C. 1920. This view looks to the south, toward the Pine Hills. Among the people pictured here are George Crowell, Charlotte Leach, Arthur Leach, Mary Leach, Simie Crowell, and Herbert Blanchard.

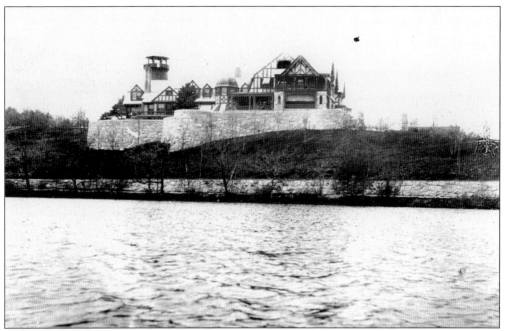

CHILTON HALL, THE FORGES, C. 1900. Built in 1895 by Eben Jordan Jr., this imposing summer home was demolished in the 1930s by the heirs of its second owner, Sherman Whipple. The view looks northwest across Forges Pond from Old Sandwich Road.

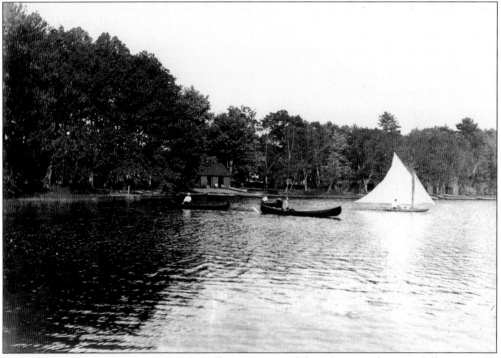

BOATING ON FRESH POND, C. 1890. Different copies of this photograph name different ponds as the setting for this scene, but it seems to be Fresh Pond in Manomet, where canoes and sailboats plied the waters with evident enjoyment.

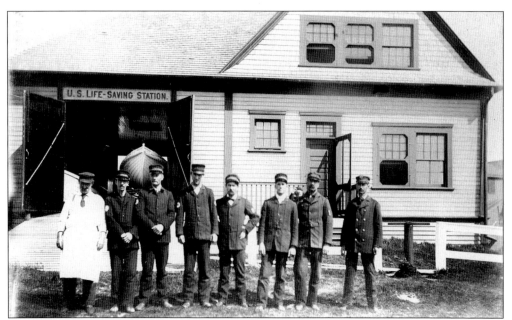

THE MANOMET POINT LIFESAVING STATION, C. 1900. The man wearing the apron at the far left is Roscoe Sampson. Third from the left is a Mr. Robinson, and Capt. Augustus Rogers is at the far right.

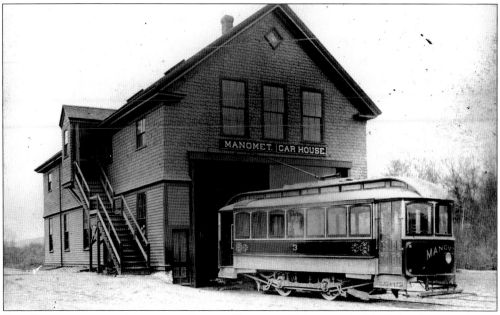

THE PLYMOUTH AND SANDWICH STREET RAILWAY BARN, C. 1900. This photograph was taken from a point on State Road in Manomet just north of where the Star of Siam restaurant is today. The Plymouth and Sandwich Street Railway was founded in 1899. The original intent was to continue service south to Sandwich, but the line operated only between the Hotel Pilgrim and Fresh Pond, about six miles south on today's Route 3A. Although tracks and overhead feed wire were extended to Sagamore by 1916, they were never put into public service. The company went out of business in 1918.

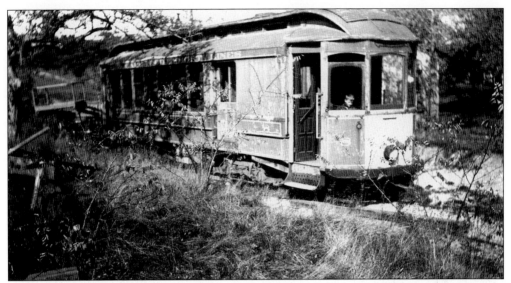

PLYMOUTH AND SANDWICH CAR NO. 8, JUNE 1920. Left behind when the line's southern extension failed in 1918, this victim of the automotive mass market was left in Sagamore to rot away.

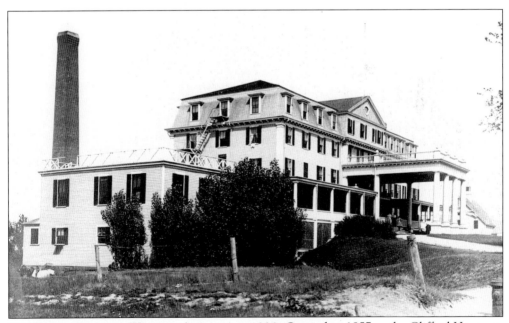

THE HOTEL PILGRIM, WARREN AVENUE, C. 1930. Opened in 1857 as the Clifford House on the hill overlooking Plymouth Beach, the hotel was bought by the Brockton and Plymouth Street Railway Company in 1891 and renamed the Hotel Pilgrim. In 1903, the building was renovated in the Colonial Revival style. The hotel closed in the 1950s.

THE INTERSECTION OF RIVER STREET AND CLIFFORD ROAD, C. 1900. This view looks northeast across Eel River basin. In 2004 the River Street Bridge (left) was reopened by the state. The large houses at the upper left are on the Hornblower family estate, where Plimoth Plantation is today.

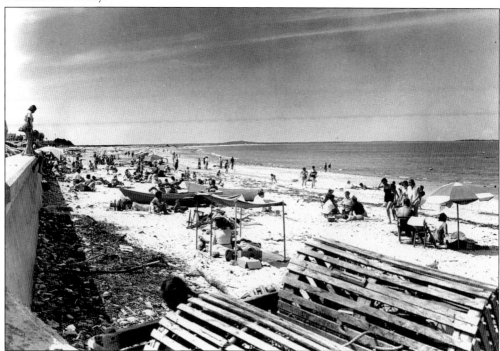

A SUMMER'S DAY AT PLYMOUTH BEACH, C. 1950. Spending a day at the beach has been a popular leisure activity with Plymoutheans since the 18th century, although the love of sun was a novel innovation a century or so later. This is a northward view from opposite the Warren Avenue entrance.

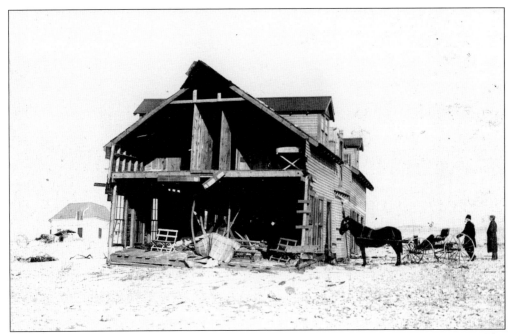

THE RUINS OF THE COLUMBUS PAVILION, PLYMOUTH BEACH, NOVEMBER 26, 1898. The great storm known as the Portland Gale damaged the Pavilion (which was soon torn down), destroyed the public water system, and demolished all but one of the 17 cottages on the beach. C. L. Willoughby, the owner of the Columbus Pavilion and many of the cottages, lost over $10,000 in property during the gale.

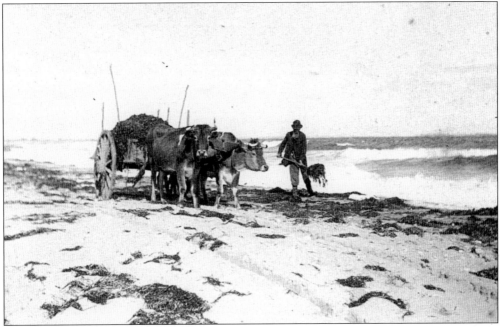

COLLECTING SEAWEED ON CLARK'S ISLAND, C. 1890. Seaweed was used for fertilizer and also as insulation around house foundations and in walls. Collecting seaweed in this view is Albert M. Watson (known as Mort).

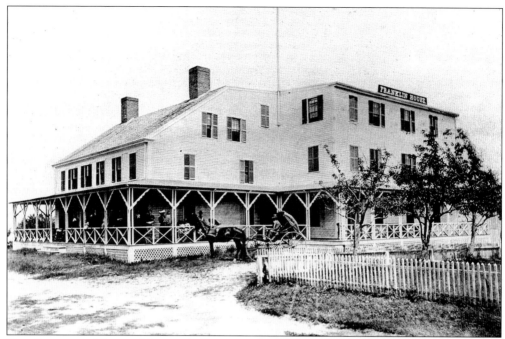

THE FRANKLIN HOUSE, MANTER'S POINT, C. 1890. The building is a private home today, and now lacks the porches and addition seen in this photograph. Warren Avenue, which runs past on the west side, was called Franklin Street when it was opened c. 1850. This view looks southeast from Manter's Point Road.

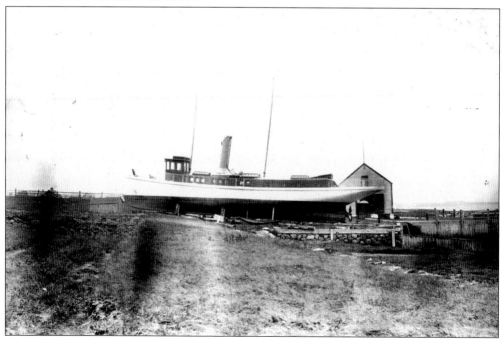

CHARLES I. LITCHFIELD'S YACHT MAYFLOWER, C. 1890. In the off-season, the Litchfield yacht, seen here below 72 Warren Avenue, was put into winter storage on a slip behind the house and covered with a moveable shed.

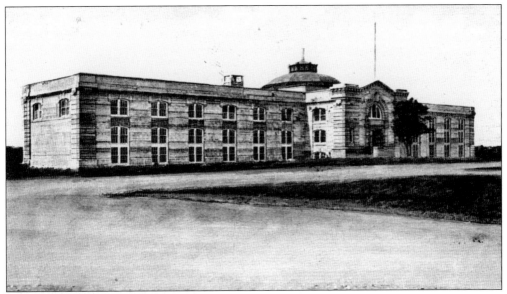

THE PLYMOUTH COUNTY HOUSE OF CORRECTION, C. 1909. The prison was built on Obery Street in 1909 and was torn down in 2000 after the completion of the new county facility on Long Pond Road. In 2004, a new county courthouse was being built on the site to replace the 1820 courthouse in the center of town.

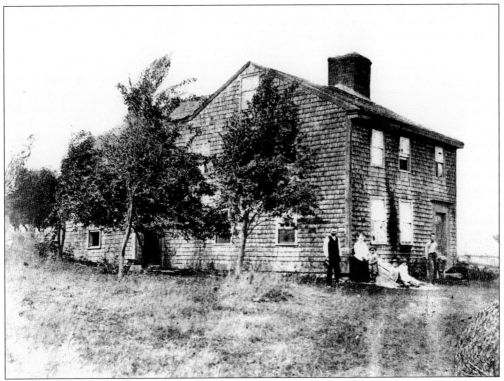

THE NATHANIEL MORTON HOUSE, SANDWICH STREET, C. 1880. Looking northeast, this view shows William Whiting and family. The house originally belonged to Nathaniel Morton (1613–1685). It was replaced by the present house at 160 Sandwich Street.

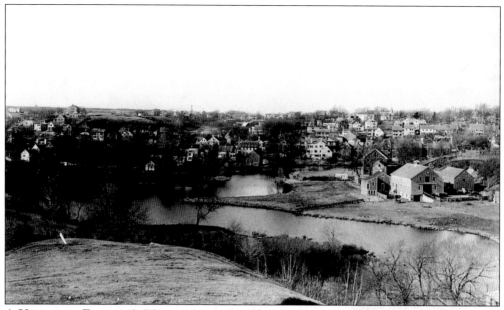

A VIEW FROM FRAWLEY'S MOUNTAIN, 1890. This view looks north from Rogan's Pasture (off Birch Avenue) toward Poorhouse Pond (now Jenney Pond). Note the barn and outbuildings of the Plymouth Poor House (right foreground) and the bare summit of Cow's Hill (upper left).

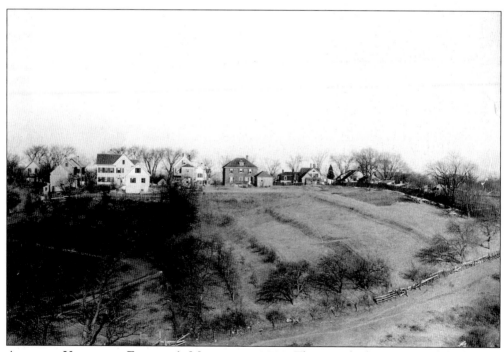

ANOTHER VIEW FROM FRAWLEY'S MOUNTAIN, 1890. This view looks east toward the back of Mayflower Street.

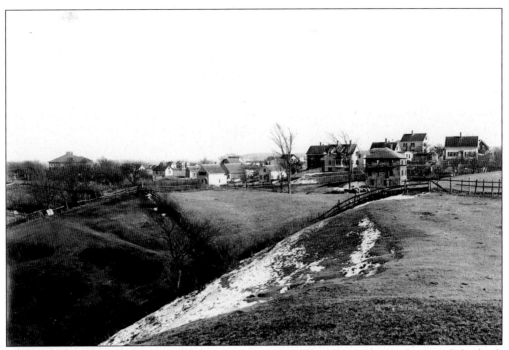

A THIRD VIEW FROM FRAWLEY'S MOUNTAIN, 1890. This view looks south toward the back of Stafford Street. The Mount Pleasant School is on the left.

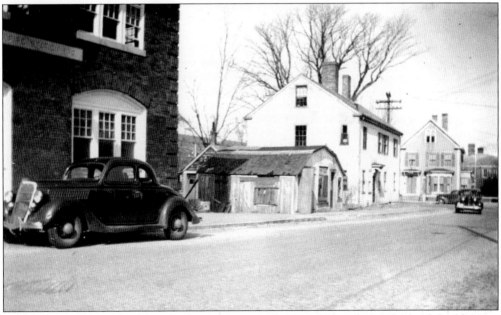

THE FOOT OF SOUTH STREET ON THE NORTH SIDE, APRIL 22, 1939. The brick building on the left served the town as a firehouse, a school, and one of politician William "Cozy" Barrett's headquarters. Although that building is still there, the house on the corner of South and Sandwich Streets and the house on the right (where the Texaco station is today) have long since departed. Note the corner of the old high school (now the Plymouth Town Hall) on Lincoln Street at the extreme right.

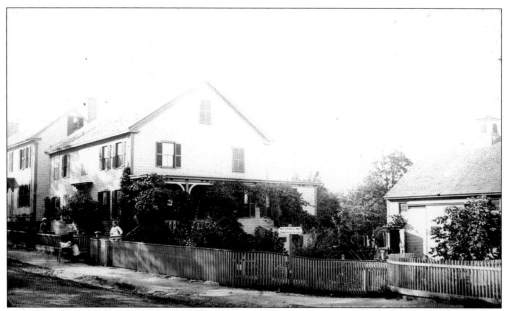

THE BARNES HOUSE, SANDWICH STREET, C. 1885. This view looks northeast toward the corner of Barnes Lane. The intersection is now the corner of Lincoln Street, which was laid out in 1891 over the old private track of Barnes Lane.

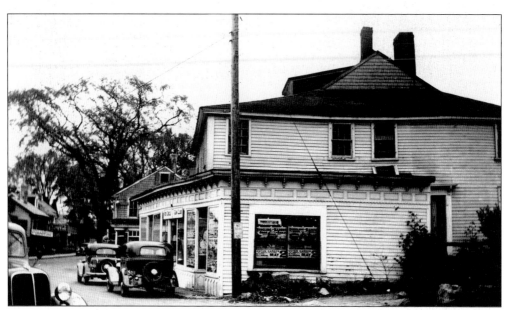

BURNHAM'S FOOD STORE, SANDWICH STREET, 1938. In a view looking south from the intersection with Main Street Extension, this area is now the parking lot in front of Friendly's and Mayflower Realty.

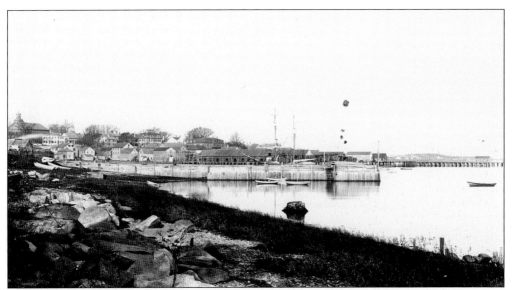

PLYMOUTH ALONGSHORE FROM STEPHEN'S POINT, C. 1880. Looking north along the waterfront, this view shows Atwood's Wharf in the center foreground, where the Plymouth Yacht Club is today. The wharf seen in the distance on the right is Long Wharf (originally over 900 feet long), at the foot of North Street.

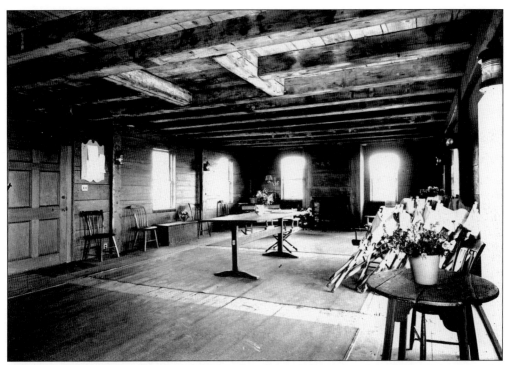

THE PLYMOUTH YACHT CLUB, C. 1945. Before this building housed the yacht club, it was the storehouse of the Atwood-Robbins Lumber Company, on Union Street.

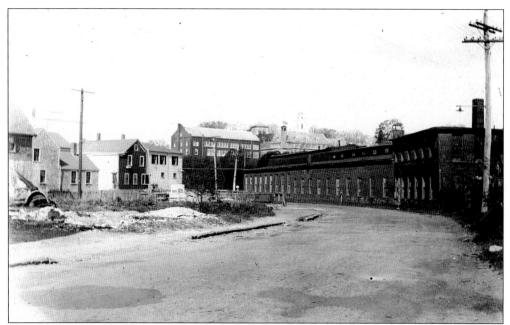

THE PLYMOUTH FOUNDRY, UNION STREET, C. 1940. Established by William Drew in the 1840s, the foundry cast stoves and hollowware (pots and pans) until it went out of business in 1935. The site, which was later occupied by Plymouth Marine Railway and Shiretown Motors, is now the location of Zebra Visuals and other businesses.

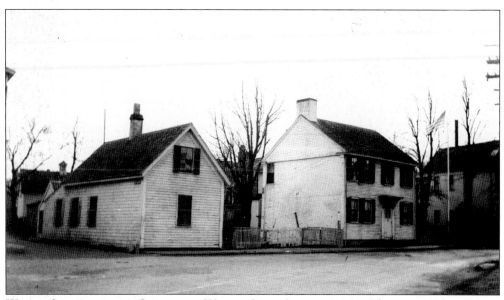

WATER STREET AT THE CORNER OF WATER CURE STREET, 1933. This area is now the site of the parking lot for the Water Street Café. A corner of the Cappannari Brothers store (the Water Street Café) can just be seen at the far left. The house at the far right was occupied by "Mary Jack" Costa.

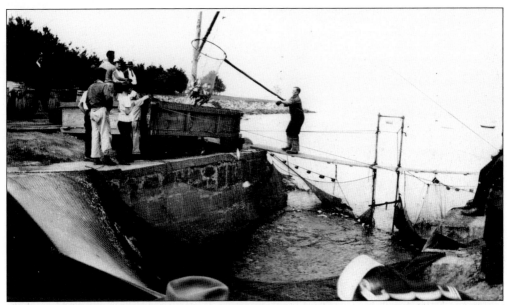

NETTING HERRING (ALEWIVES) AT THE MOUTH OF TOWN BROOK, 1943. The town of Plymouth secured a number of the herring that were on their way to spawn in Billington Sea (at the source of the brook) and transported them overland so that the fish would not face the difficulty of making the run up the river past the many dams and mills. The town undertook this effort in order to ensure that the fish would successfully reproduce.

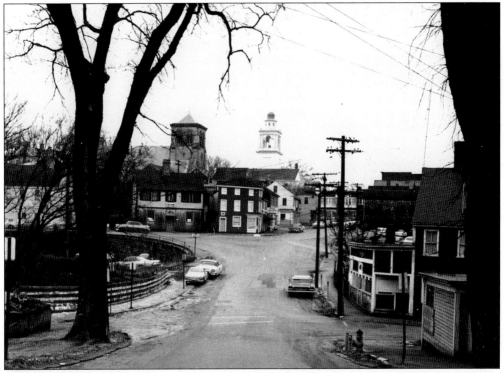

MARKET STREET, 1964. This view looks north from Pleasant Street during the urban renewal project that swept away most of the buildings in this picture.

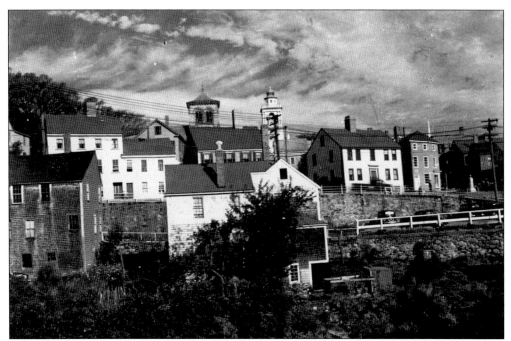

THE FOOT OF SUMMER STREET, C.1940. The towers of the Unitarian and Congregational churches can be seen in a view looking north from Bass Place (off Pleasant Street). Just below them are the roofs of houses on High Street. The main level of houses is on Summer Street, and the lowest two dwellings are on what was once Mill Street, but they could also be accessed from Summer Street. Market Street is at the extreme right.

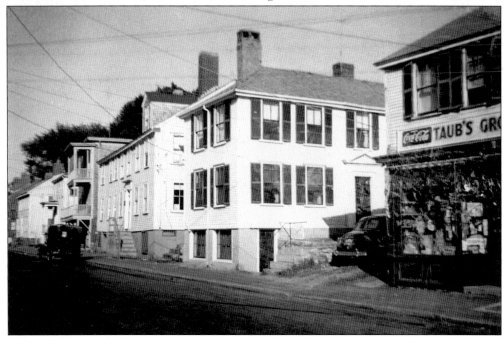

TAUB'S MARKET, 27 SUMMER STREET, C. 1950. This view looks northwest toward the area now occupied by the John Carver Inn entrance.

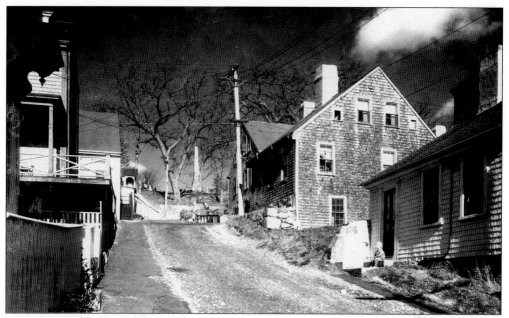

SPRING STREET, C. 1930. This is a view to the north toward the Cushman Monument on Burial Hill. Spring Street was demolished during the Plymouth redevelopment project in the 1960s. Today its course is marked by a short, steep paved path west of the John Carver Inn.

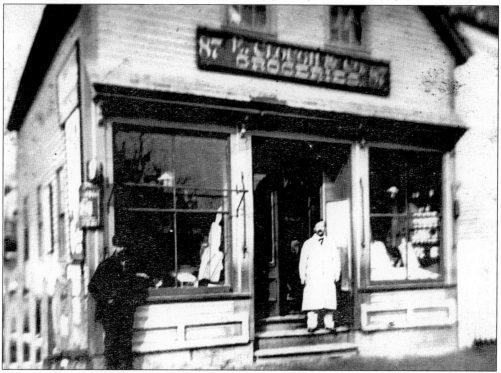

E. CLOUGH AND COMPANY, 87 SUMMER STREET, C. 1895. Edward Clough Sr. opened this market near the corner of High and Summer Streets in 1895. It was across from the entrance to Newfield Street.

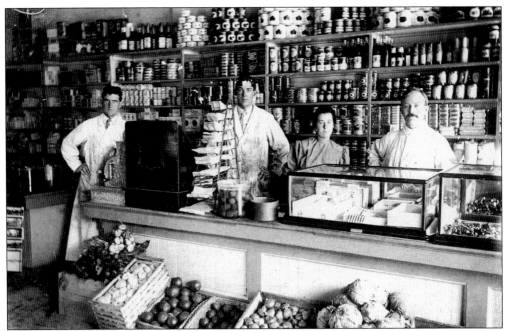

THE INTERIOR OF E. CLOUGH AND COMPANY, C. 1895. Shown, from left to right, are two unidentified men, Mary Alice Raymond (bookkeeper), and Edward Clough Sr.

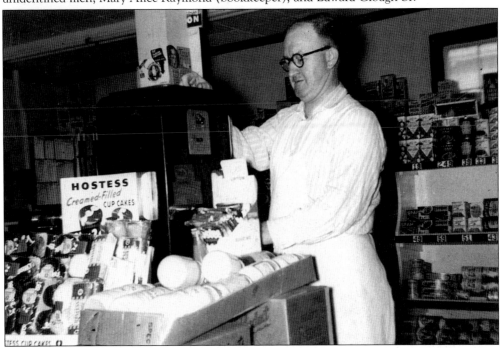

EDWARD M. CLOUGH JR. MEASURES COFFEE FOR GRINDING, C. 1950. In 1938, Edward Clough Jr. inherited his father's Summer Street store, which in 1918 had moved across Summer Street to the former Atwood market, at 84 Summer Street, on the corner of Willard Place. The Clough store and its genial proprietor were highly valued neighborhood fixtures who fell victim to redevelopment in 1963.

HARRY FRIM'S BARN, VACANT LANE, 1962. Harry Frim was a local junkman who kept his horse and wagon in this barn though the 1950s. A pleasant if physically unattractive old man, he was teased by children who shouted his hated nickname of "Onions," eliciting from him a crack of his whip and snarled threats. Vacant Lane ran east from the end of Edes Street to Russell Street.

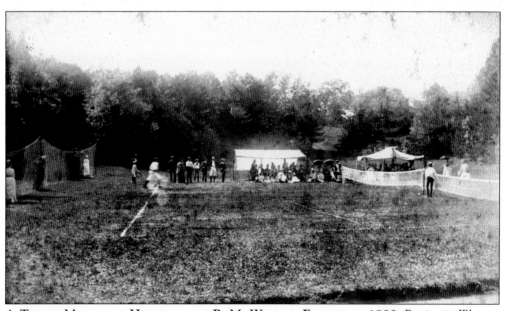

A TENNIS MATCH AT HILLSIDE, THE B. M. WATSON ESTATE, C. 1880. Benjamin Watson was a noted naturalist and nursery owner. His house, on Summer Street, was surveyed by his friend and fellow naturalist Henry David Thoreau on October 6, 1854.

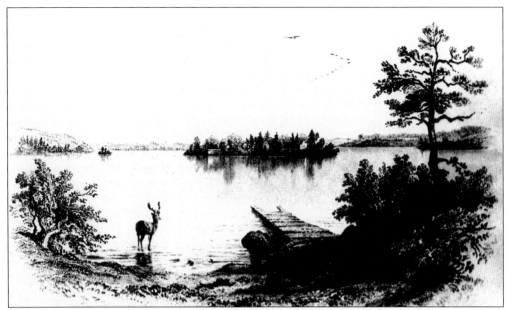

SEYMOUR'S ISLAND, BILLINGTON SEA, 1853. One of Plymouth's first bowling alleys was located on Seymour's Island, and the shore area had been a favorite resort for social parties since the 18th century, when engineer Benjamin Seymour built his farm on the property. This view looks south from Hospital Point. This print is from W. H. Bartlett's *The Pilgrim Fathers*.

NATHANIEL MORTON, NEAR BILLINGTON SEA, MORTON PARK, C. 1900. Plymoutheans have always enjoyed the quiet solitude of their native woods as well as more active leisure pursuits. For those who had no private pond lot or family cottage in which to enjoy the outdoors, Nathaniel Morton and others acquired and donated land around Billington Sea and Little Pond to be Plymouth's first public park.

DOUGLAS' POINT, BOOT POND, 1890. Boot Pond was a popular summer resort for private cottage owners who enjoyed the relaxing sense of the natural surroundings at the end of the 19th century. Boot Pond was never as exclusive as Long Pond, however.

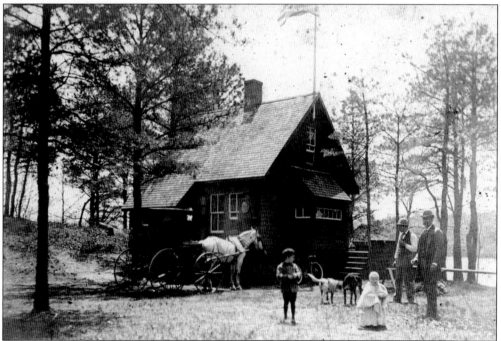

THE SQUIRREL'S NEST, BOOT POND, C. 1895. Built cooperatively in 1893 by five friends, the cottage known as the Squirrel's Nest was shared by their families and a continuous series of guests, who enjoyed the rustic pleasures of the location with boating, fishing, hunting, traditional Yankee cookery, and croquet.

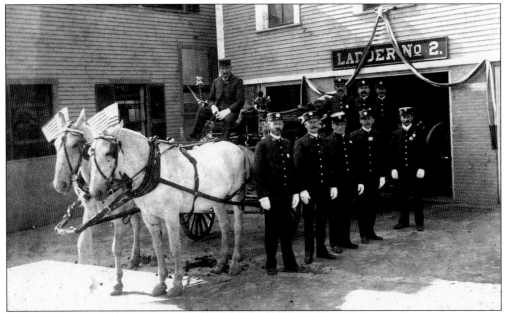

PLYMOUTH FIRE DEPARTMENT LADDER NO. 2, MARKET STREET, C. 1890. At the time this photograph was taken, the fire engine was stored beneath the old Town House (now referred to as the 1749 Courthouse) in Town Square. The firefighters pictured are, from left to right, as follows: (first row, standing) Capt. B. Holmes, unidentified, Bill Wall, Duncan Ryan, and Alex Kierstead; (second row, on truck) George Wall (driver), Charles Paty, Louis Covell, and unidentified.

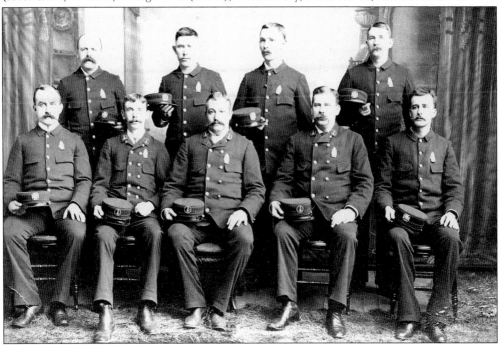

PLYMOUTH FIRE COMPANY NO. 1, 1900. From left to right are the following: (first row) Henry S. Healy, James Noble, William Stockton, Timothy Downey Jr., and Everett Sampson; (second row) Richard Pickett, Thomas Reagan, Manuel Scott, and Michael Downey.

THE PLYMOUTH POST OFFICE AND THE TOWN TREE, TOWN SQUARE, C. 1870. The post office building was constructed by Thomas Murdock before 1700 on the site of Gov. William Bradford's original house. The post office, a favorite lounging place for Plymouth men, was moved in 1877. The tree had been the official place for posting public notices before it was blown down in a storm on December 26, 1885, killing a woman in the process.

SANDWICH STREET TENEMENTS, THE 1920s. Pictured in a view looking northwest, toward the junction of Sandwich and Market Streets, Gale's Block is the long building on the left. The small shop in the middle was a pool hall. These buildings were on the south bank of Town Brook, across from where Friendly's is today.

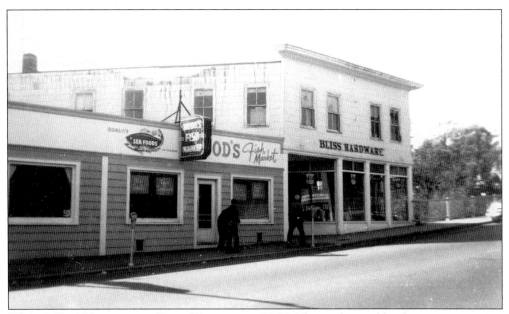

WOOD'S FISH MARKET AND BLISS HARDWARE, 1960. The market and hardware store are seen in a view looking west from a spot in front of the Old Colony Theater (now the Landmark Building). The stores at this intersection had entrances on both Main Street Extension and Sandwich Street. Wood's moved to the Plymouth town pier in the wake of the redevelopment project that demolished this building. The site today is just a grassy bank.

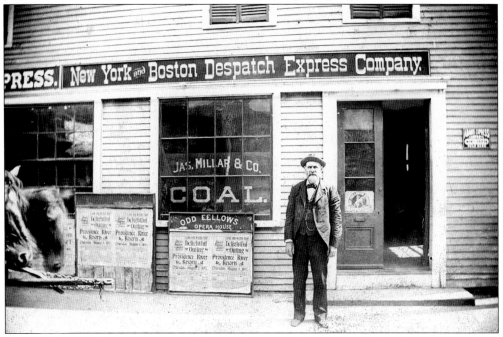

UNCLE GEORGE FINNEY AT THE WESTON EXPRESS COMPANY, 1897. The express office, which also represented the Millar Coal Company (whose main operations were on Millar's Wharf), was located on the northeast corner of Main and Leyden Streets. It was later the location of Jordan Hardware.

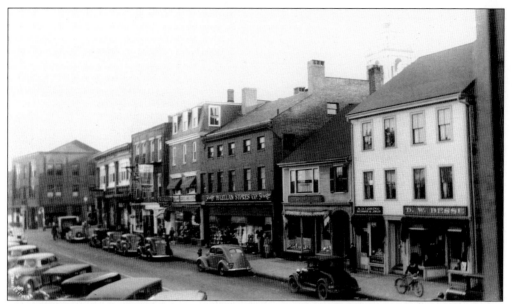

THE WEST SIDE OF MAIN STREET, 1937. Old-timers can remember when Main Street was a functioning downtown district, with such stores as Cooper's Drug, the Plymouth Men's Shop, McClellan's (a dime store), Danforth's Bakery, and Besse Shoes.

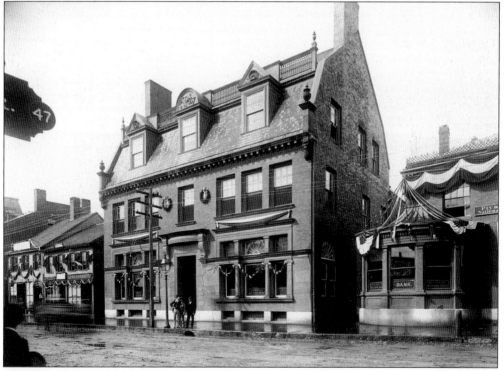

THE PLYMOUTH SAVINGS BANK, 1889. Completed in 1888, this impressive structure housed the Plymouth Savings Bank, the Old Colony Bank, Plymouth Library (until 1904), the Old Colony Club (until 1893), and the local art association, the Black and White Club. The upper story was removed in the 1950s, and a new facade was added to the building.

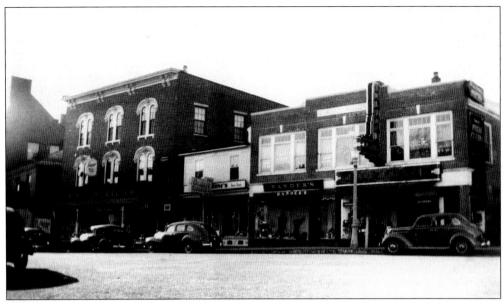

THE WEST SIDE OF MAIN STREET, SHIRLEY SQUARE, C. 1950. The buildings in this view are, from left to right, the Plymouth Savings Bank (at left edge), Plymouth Five Cent Savings, Woolworth's (in the old Davis Building), Gambini's Luncheonette, and the Puritan Clothing Company.

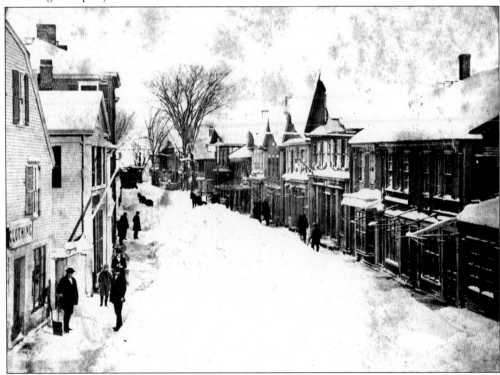

MAIN STREET, FEBRUARY 17, 1871. This early stereopticon image shows Main Street under an impressive snowfall. Note the changes that had occurred by the time the following picture was taken.

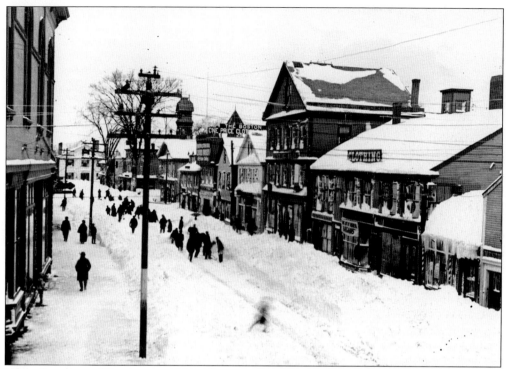

MAIN STREET IN WINTER, C. 1890. The men are clearing the center of the street, where the Plymouth and Kingston Street Railway track had been. Note the fire tower above the old Central Station, near the center.

THE CORNER OF MAIN AND MIDDLE STREETS, MAY 14, 1946. Seen in a view to the east, Scottie's Barbershop and Reliable Cleaners were soon relocated to make way for the new Colonial Restaurant.

MIDDLE STREET HOUSES BEING DEMOLISHED, JULY 29, 1964. These old houses on the south side of Middle Street were removed to create the parking lot that exists there today. The tall cement building at the right end of the row housed the Old Colony Memorial newspaper offices. The building was soon torn down, and the paper moved its operations to the site of the old town piggery on Long Pond Road.

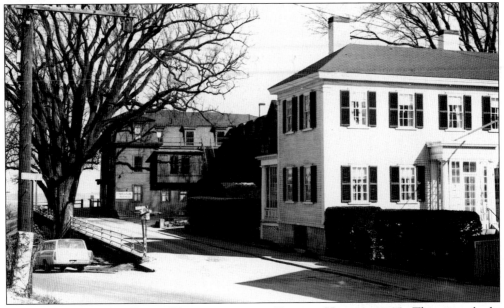

THE OLD PLYMOUTH ROCK HOUSE AND THE TAYLOR HOUSE, 1965. This view looks southeastward from North Street. The Plymouth Rock House hotel (at left), on Carver Street, closed in the late 1950s, and the building was used as a boys school before it was purchased by a wax museum company that had opened a similar museum in Gettysburg in 1962.

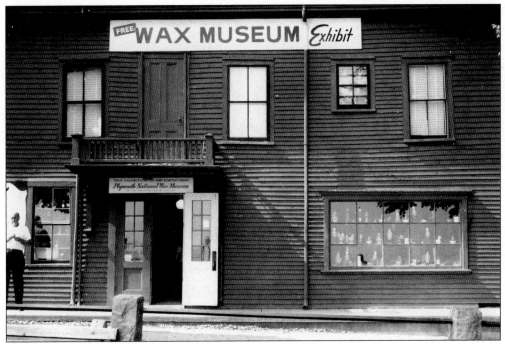

CARVER STREET, 1965. The Plymouth National Wax Museum's preliminary exhibit was housed in the old Plymouth Rock House before that building was replaced with the new wax museum building, which closed in 2004.

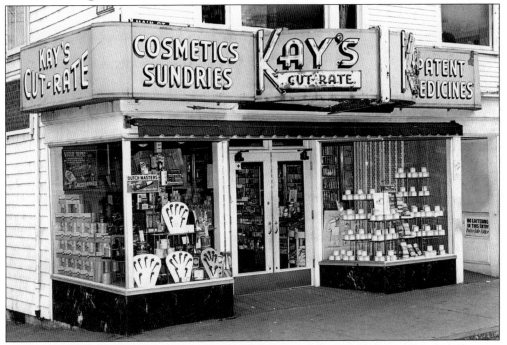

KAY'S CUT-RATE, 67 MAIN STREET, C. 1950. A popular predecessor of today's bargain outlets, Plymouth's own Cut-Rate store is shown at its location in Shirley Square, at the corner of North and Main Streets.

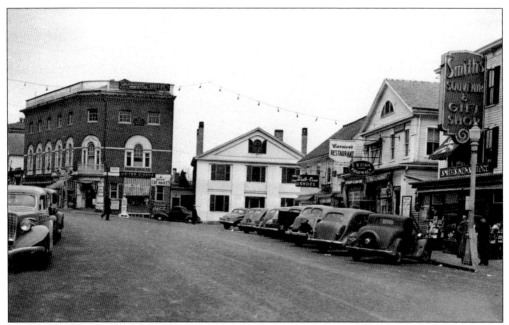

SHIRLEY SQUARE, THE 1930s. In this view looking north along Main Street, note the elegant Nathaniel Morton House (at center), which was replaced by the First National Stores building (now the Sovereign Bank) in the 1950s.

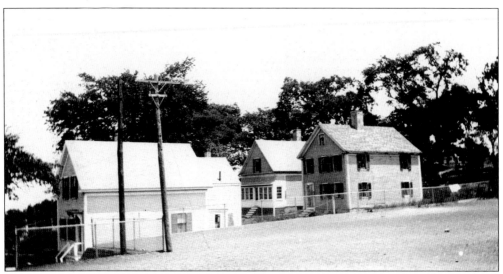

THE UPPER END OF SOUTH RUSSELL STREET AND BURIAL HILL, 1935. This view looks southeastward across the Cornish School playground, which is now a parking lot for the Plymouth District Court.

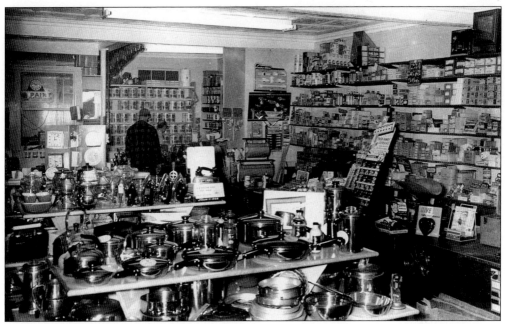

THE PLYMOUTH HARDWARE COMPANY, MAY 8, 1953. The hardware company appears in its new location after a move from 46 Court Street to the larger location next-door at 42–44 Court Street. Plymouth Hardware and Neri Plumbing shared the space at this time. Vincent and Avedo Neri, who had worked at the Puritan Mills before World War II, were in the plumbing trade. Henry Govoni managed the hardware business.

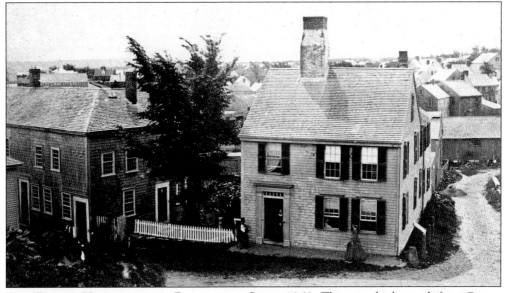

THE TURNER HOUSE AND THE BLACKSMITH SHOP, 1863. This view looks south from Carver Street at what is now the entrance to Brewster Gardens. The David Turner house, at the foot of Leyden Street, is at the center. Turner's son was Capt. Lothrop Turner, whose Swedish wife, Marie de Verdier, founded the Fragment Society (Plymouth's oldest charity) in 1818 and taught arts to Plymouth girls. The lane at the right, now a driveway for the brick-ended house, led to the Robbins Cordage Company ropewalk.

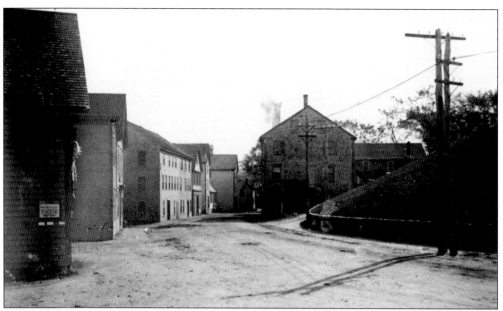

WATER STREET AND COLE'S HILL, C. 1890. Pictured in a view looking south from a spot near Plymouth Rock, the buildings that once lined both sides of the street were removed in part by the Pilgrim Society through a bequest by Henry Stickney of Baltimore. Note that the grass banking does not yet extend south of a point below the foot of Middle Street.

WATER STREET AND COLE'S HILL, C. 1912. The old Hammatt Billings canopy can be seen near the center of this photograph. The Cole's Hill banking has been extended farther south; note the position of the long three-story building in this picture and the preceding one. The last building on the west side of the street, the Old Curiosity Shop, was removed from about where the two trees are on the street in this view.

The Completion of First Plymouth Rock Canopy, 1867. The first canopy was designed by Boston architect Hammatt Billings, who also designed the Forefathers' Monument. The cornerstone was laid on August 2, 1859, and the work was completed in 1867. Note the crane for lifting stonework behind the canopy.

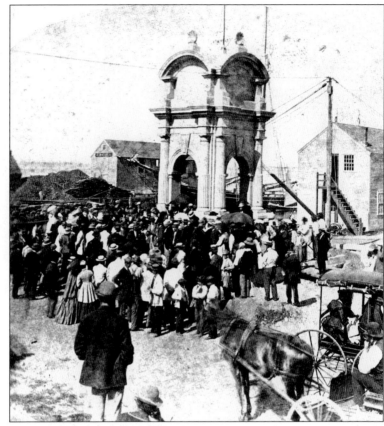

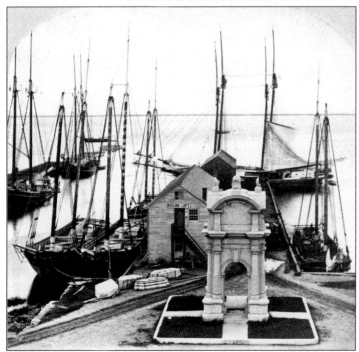

A Picturesque Fishing Fleet by Plymouth Rock, c. 1870. The gathering of schooners indicates the importance of the fishing trade in Plymouth's history. Note that there is no visible rock in Hammatt Billings's canopy, as the upper half was still in front of Pilgrim Hall and was not reunited with its lower section (in the floor recess at the middle of the monument) until 1880.

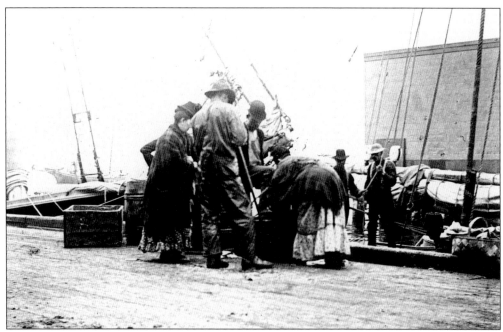

FISH FRESH FROM A BOAT ON DAVIS WHARF, THE 1890S. In this view looking south toward Nelson Wharf, frugal Plymouth housewives seek a bargain as cod and haddock are unloaded from a fishing schooner.

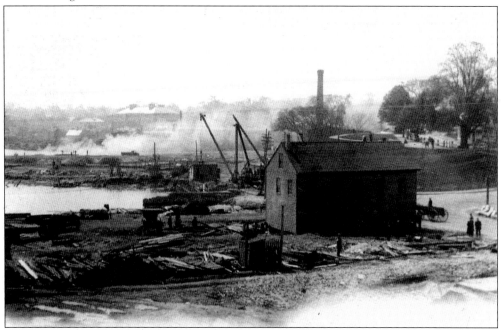

THE DESTRUCTION OF PLYMOUTH'S OLD WATERFRONT, 1920. The town's seven Water Street wharves and associated warehouses, sail lofts, and chandleries, which had once been the economic core of the town, were obsolete and in disrepair by World War I. They were removed for the 1921 tercentenary, and the area became the Plymouth Rock State Park. This view looks south from where the State Pier is today.

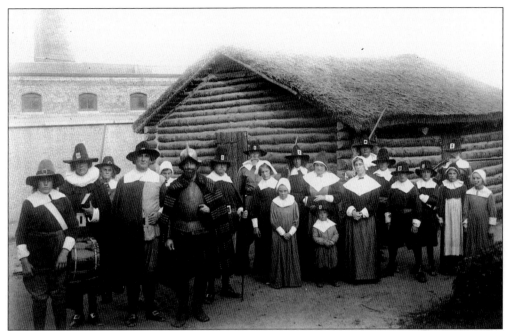

THE PILGRIM LOG CABIN, LEYDEN STREET, 1921. The cabin is pictured in a view to the southeast toward the Plymouth Electric Company building (now the site of the Brewster Gardens entrance). The structure was built for the Pilgrim tercentenary, when it was believed that the colonists had built log cabins as the pioneers of the frontier had done. The cabin was located just east of the brick-ended house at the foot of Leyden Street, on the site of the Turner house.

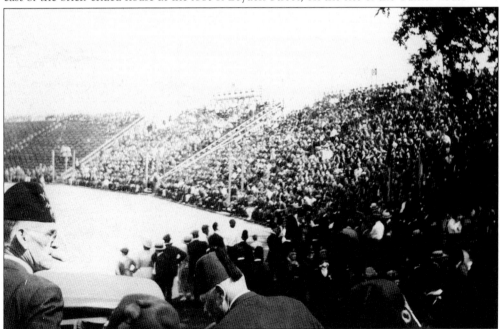

VISITING SHRINERS WATCHING THE TERCENTENARY PARADE DRILL, AUGUST 6, 1921. Massive bleachers were erected on Cole's Hill to accommodate the thousands of visitors who attended the performances of *The Pilgrim Spirit*, the tercentenary pageant by George P. Baker.

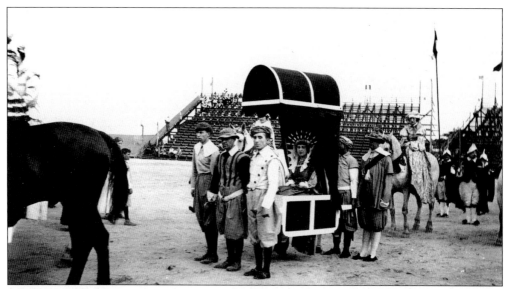

THE FRENCH AMBASSADRESS AWAITING HER ENTRANCE, AUGUST 1921. The Ambassadress, played by Louise Washburn, and chair carriers Arthur Quinchen, François Verniere, Jules Carlier, and Albert Verheyn were among the 1,300 costumed personnel who were featured in *The Pilgrim Spirit* pageant.

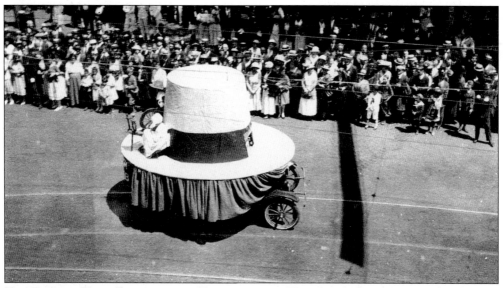

THE PILGRIM HALL FLOAT IN THE TERCENTENARY PARADE, AUGUST 1921. The ultimate Pilgrim symbol is the tall hat with the huge buckle, although the Pilgrims never wore such a thing. Here we see an example of this imagery in a parade float on Main Street. Priscilla and her spinning wheel are perched on the brim.

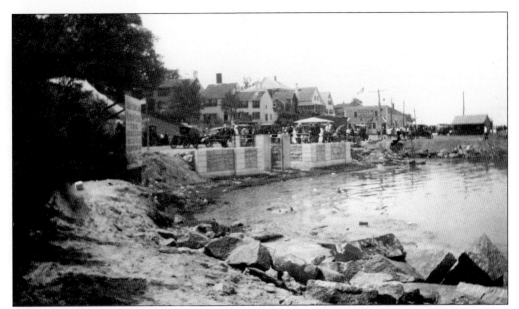

PLYMOUTH ROCK IN ITS PERMANENT RESTING PLACE, JULY 22, 1921. Although the new McKim, Mead, and White canopy was not ready until November 1921, the famous rock was back in place for *The Pilgrim Spirit* tercentenary pageant, which had its first presentation on July 13, 1921. Anarchist Bartolomeo Vanzetti left the Plymouth Cordage Company to work on the new breakwater.

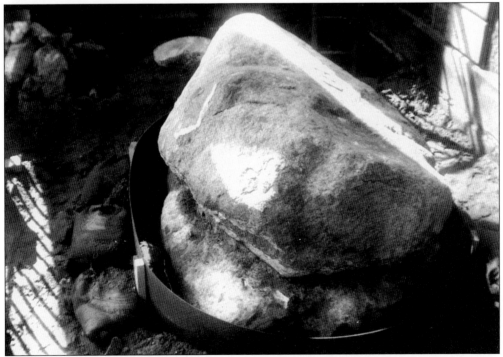

RECASTING THE PLYMOUTH ROCK FOUNDATION, 1956. Once the rock was in place, the upper and lower halves were more securely united with a cement foundation. As can be seen, the lower half is about the same size as the visible upper section.

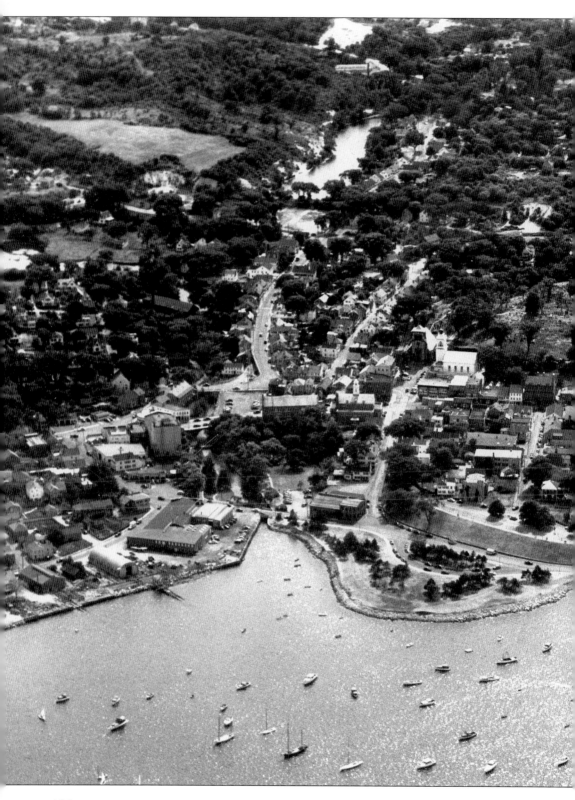

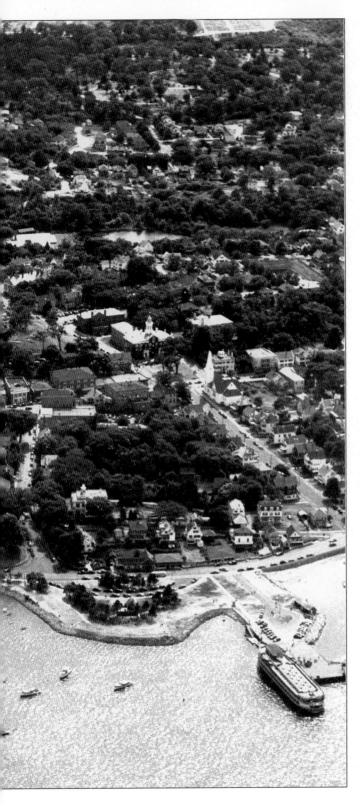

DOWNTOWN PLYMOUTH, 1949. This scene shows the Plymouth that is remembered by older generations of contemporary Plymoutheans—the downtown area that existed before the changes of the 1960s took place. Many of the buildings shown in this book are seen here. Note the Boston Boat at the State Pier; the Summer Street–High Street complex that was demolished in the 1960s (middle left); and Rogan's Pasture on Cannon Mountain (upper left), where the Newfield Nursing Home is today. Part of Mabbett's (extreme right) can be seen where the Governor Bradford Hotel and the Isaac's Restaurant parking lot are now. Near the mouth of Town Brook is the old Plymouth Electric Company, and the Old Colony Theater can be seen to the left.

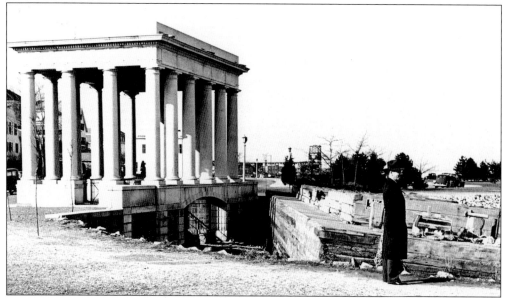

"A CLOSE SHAVE FOR AMERICA'S MOST FAMOUS SHRINE," NOVEMBER 1935. John Searles took this photograph of the huge barge that had been washed into Plymouth Harbor and almost onto Plymouth Rock in the tremendous gale of November 17, 1935. Had the tides been different, the barge might have been the cause for a third portico to be built over Plymouth Rock.

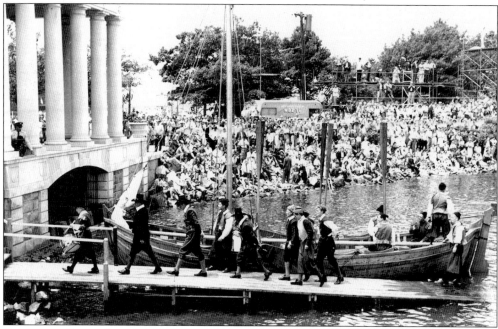

CREWMEN COME ASHORE FROM THE MAYFLOWER II, JUNE 13, 1957. Walking behind drummer Harold Boyer (far left) are, from left to right, Alan Villiers, Warwick Charlton, Stuart Upham, Godfrey Wicksteed, Joe Meany, and Graham Nunn. The long-anticipated arrival of the *Mayflower II* at the end of the 55-day sail across the Atlantic was witnessed by thousands of visitors. The 33-foot shallop that brought the crew from the ship was built in Plymouth at the Jesse Boatyard.

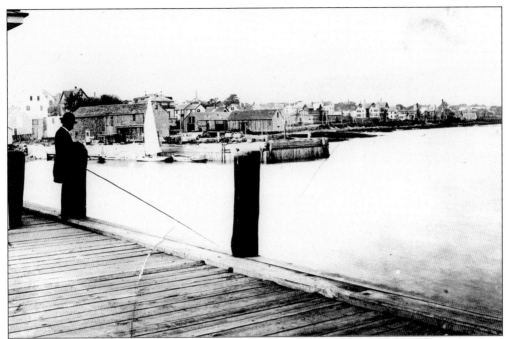

THE PLYMOUTH WATERFRONT NORTH OF LONG WHARF, 1890. A lone fisherman looks north from the wharf (at the foot of North Street) toward Atwood's Wharf, the Plymouth Rock Boot and Shoe Company, and other Water Street buildings erected after the street was extended to Railroad Avenue in 1882.

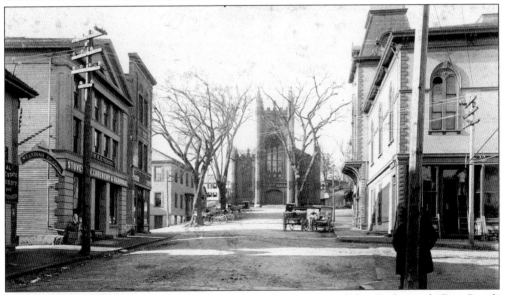

THE OLD TOWN SQUARE, C. 1890. This view looks west toward the Gothic-style First Parish church (center), a Unitarian church. The tower on the Odd Fellows building (on right) hides the Church of the Pilgrimage, a Congregational church. The alleyway to the Standish Armory (often called the Casino) and the Weston Building were removed to open the Main Street Extension in 1908. The First Parish church burned in 1892, and the Odd Fellows building burned in 1904.

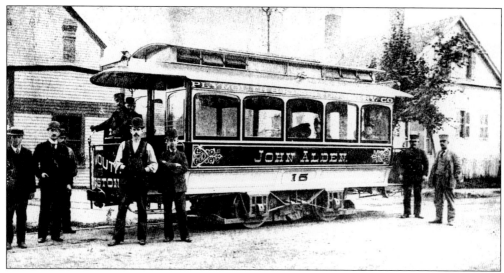

THE JOHN ALDEN STREETCAR, SANDWICH STREET, 1889. Shown is the first car to operate on the Plymouth and Kingston Street Railway, which opened on June 9, 1889. The line originally ran from Jabez Corner to Cobb's store in Kingston, near Rocky Nook. The fare was 10¢. The line was later extended southward from Kingston Center to Fresh Pond in Manomet. This picture was taken in front of the carbarn near 107 Sandwich Street. The driver is Leon Sherman.

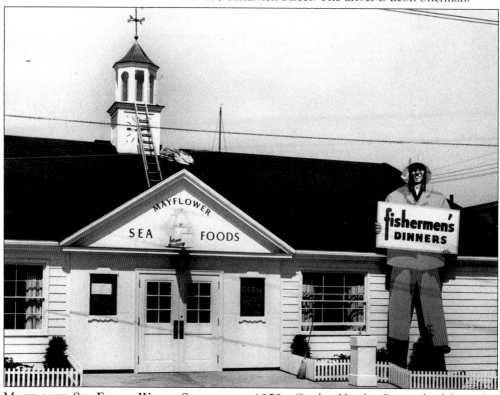

MAYFLOWER SEA FOODS, WATER STREET, THE 1950S. Gordon Howland's popular fish market and restaurant, with its big fisherman and rooftop sailboat (not pictured), was a landmark on the town pier for many years. The site is now occupied by the Cranberry House Gift Shop.

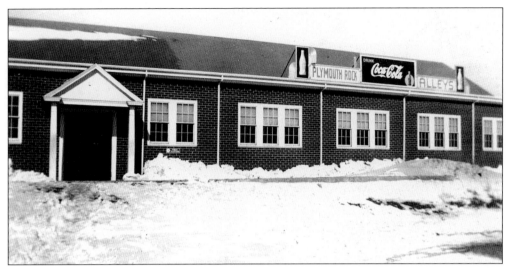

THE BOWLING ALLEY, C. 1940. Built on the site of the Bradley, Ricker Carpet Company in 1939, the Plymouth Rock Bowling Alleys offered Plymoutheans a chance to engage in the popular American pastime.

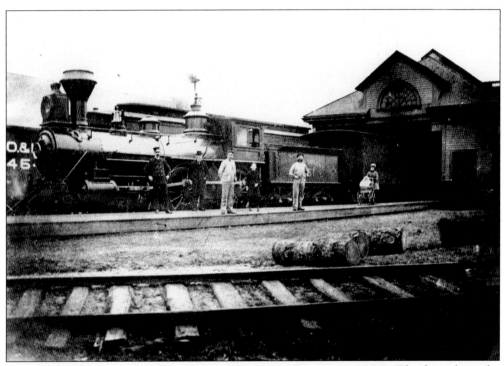

PLYMOUTH DEPOT WITH AN OLD COLONY RAILROAD ENGINE, C. 1880S. The depot (now the site of Citizens Bank) is shown in a view looking southeast toward Water Street and North Park Avenue. Rail service ceased in 1959.

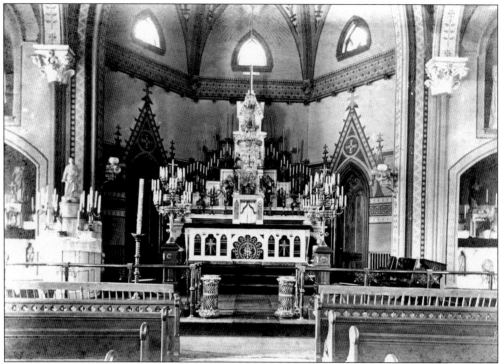

ST. PETER'S CHURCH, C. 1890. The Victorian altar and its decoration were far more elaborate and had many more candles than today's restrained modern chancel or sanctuary.

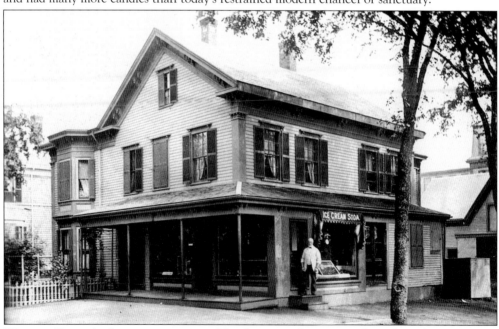

WILLIAM BURNS'S GROCERY, C. 1890. This location, the corner of North Park Avenue and Court Street, is the present site of a Mobil gas station. Scottish immigrant William Burns's grocery was a Plymouth landmark—perhaps because of its location near the railway station—and it was photographed many times.

THE INTERSECTION OF COURT AND SAMOSET STREETS, NOVEMBER 1898. This is a southward after the Portland Gale of November 1898.

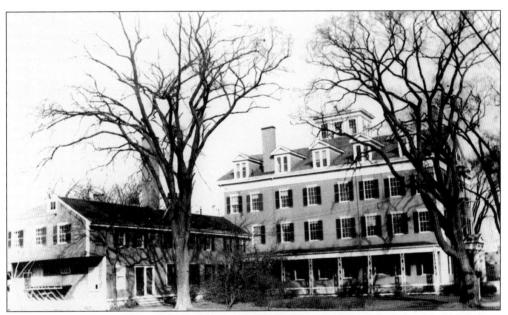

THE SAMOSET HOUSE, SAMOSET STREET, 1937. The Samoset House, built by the Old Colony Railroad in 1846, was Plymouth's first true hotel. The extension at the left included the kitchen. It burned down in 1939 and was replaced with a small restaurant bearing its name. A Gulf station and Papa Gino's occupy the site today.

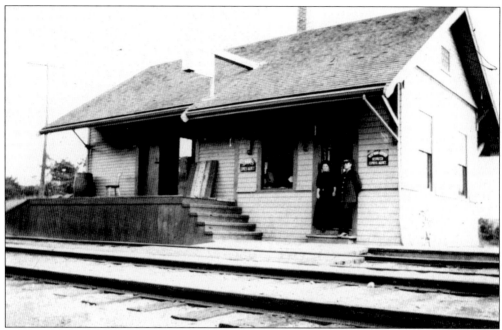

DARBY STATION, C. 1910. Darby Station, located in what is now known as West Plymouth, was near Darby Pond. It was the second station on the Plymouth and Middleboro line. Darbystation Road still can be found on the north side of Carver Road.

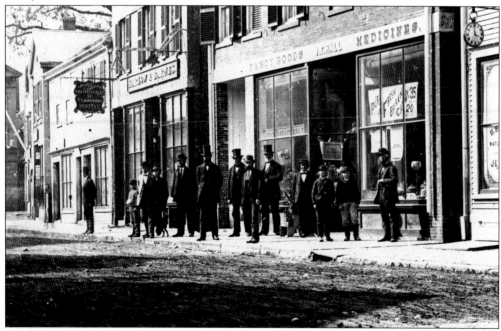

PLYMOUTH MEN ON MAIN STREET, C. THE 1860S. The shop at the center (under the Fancy Goods sign) was Charles Doten's bookshop and site of the Plymouth telegraph office. In 1872, Doten sold the store to his son-in-law Alfred S. Burbank, who began his Pilgrim Bookstore there. It became Plymouth's leading purveyor of guide books and souvenirs. This view looks south toward Leyden Street.

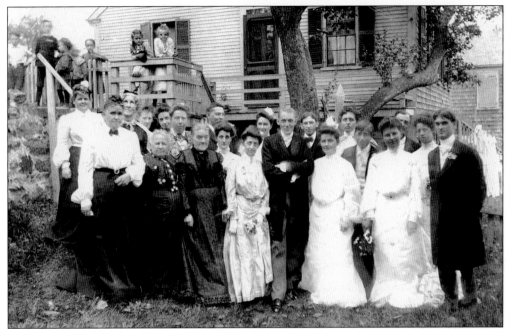

A SUMMER WEDDING ON SUMMER STREET, C. 1910. The view looks east toward 128 Summer Street, although the wedding party appears to be in the yard behind 130 Summer Street. Formal occasions such as this were celebrated with verve at the dawn of the 20th century, but they cannot compare with the elaborate and expensive spectacles that now constitute the American wedding.

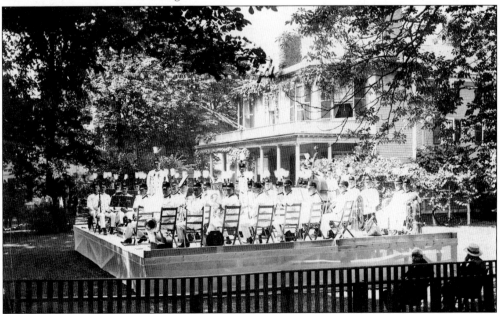

PRES. WARREN G. HARDING'S RECEPTION, AUGUST 1, 1921. This concert was held in the front yard of the Antiquarian (Hedge) House, which at that time was still on Court Street, where the Plymouth Memorial Hall is today. The house had been bought by the Antiquarian Society in 1919 but was not moved to its present waterfront location until 1924.

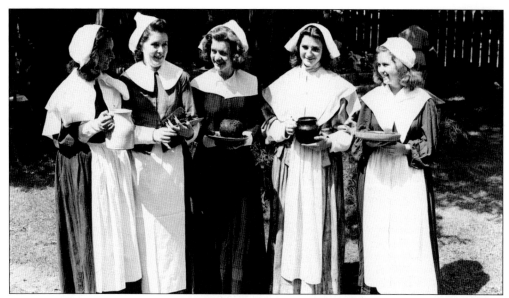

COSTUMED HOSTESSES AT THE HARLOW HOUSE BREAKFAST, 1940. From left to right are hostesses Joan Holmes, Lillian Shaw, Marcia Holmes, Jane Franks, and Ann Richards. The Harlow House breakfast offers traditional New England breakfast foods, such as baked beans, fish cakes, brown bread, and cornmeal "gems." The Harlow House has been serving breakfast around the Fourth of July each year since 1933. The event is still a high point in the summer calendar for longtime Plymouth residents and a lucky treat for the few newcomers and tourists who chance to attend.

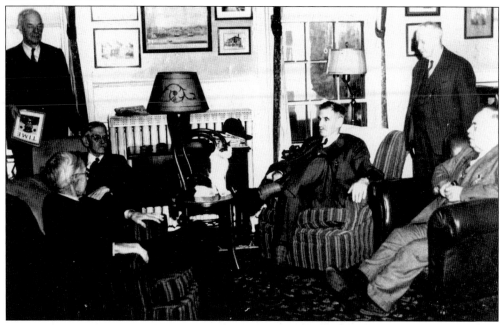

RELAXING WITH THE OLD COLONY CLUB CAT, C. 1944. Plymouth's oldest social club, the Old Colony Club, was founded in 1769. The club has an impressive collection of pictures of old Plymouth. In this view of the music room, club historian Fred Jenks is seated in front of the window.

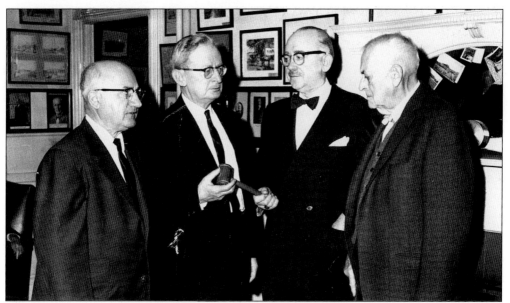

OLD COLONY CLUB OFFICERS, FOREFATHERS' DAY, DECEMBER 22, 1963. Standing in the president's room are, from left to right, William "Chick" Sgarzi, Joseph Dickson, Ronald Forth, and Oliver Edes.

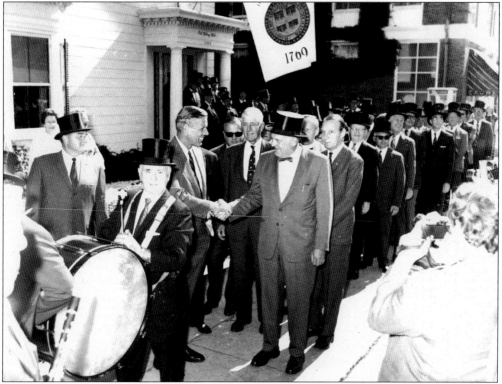

GREETING GOV. FRANCIS SARGENT, SEPTEMBER 12, 1970. Old Colony Club president Robert F. Curtis (right) greets the governor outside the clubhouse, at 25 Court Street, during the celebration of Plymouth's 350th anniversary.

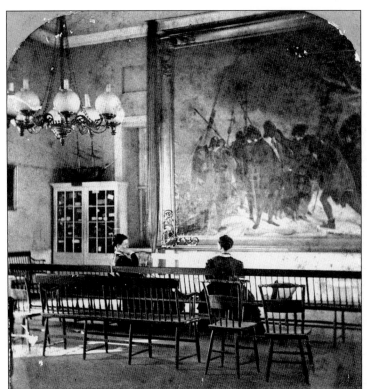

COMMUNING WITH HISTORY IN PILGRIM HALL, C. 1870. One important leisure-time activity Plymoutheans as well as visitors have enjoyed in Pilgrim Hall is the contemplation of the artistic renderings of the Pilgrims and the artifacts associated with them. The double case to the left is the original "cabinet of collections" that contained the museum's first artifacts.

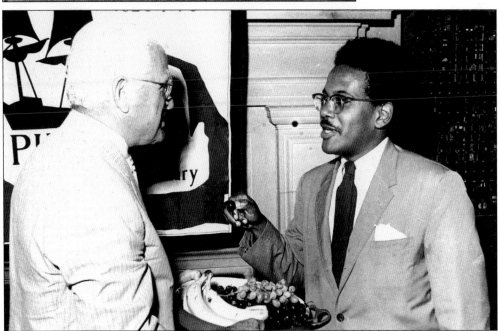

CELEBRATING THE 350TH ANNIVERSARY OF THE PILGRIM LANDING, JUNE 1971. John J. Magee (left) offers fruit to Rev. Peter J. Gomes in the library at Pilgrim Hall. Although the celebration occurred at a time when the country was divided by social disputes, the events were met with goodwill and enthusiasm by the majority of local residents and visitors.

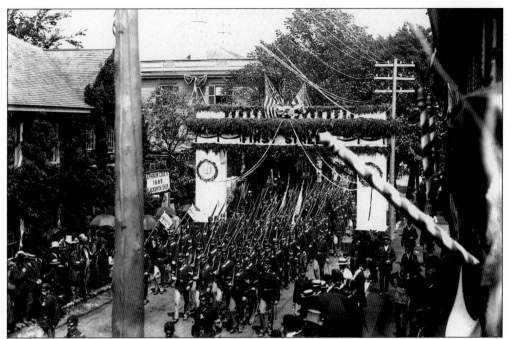

THE LEYDEN STREET CEREMONIAL ARCH, AUGUST 1, 1889. The celebration on the completion of the Forefathers' Monument was one of the largest civic events in the town's history. Many buildings in Plymouth were decorated on the day of the parade, ceremonial dinner, and ball. The Boston-based 1st Corps of Cadets was part of the 2nd Division of the 1889 parade.

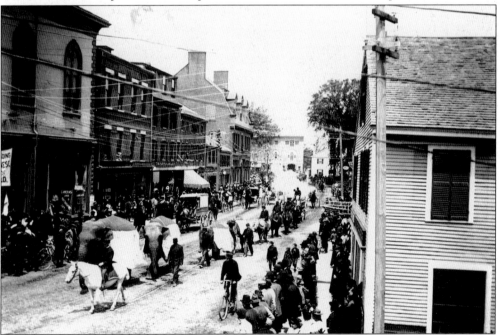

JOHN ROBINSON AND FRANKLIN BROTHERS CIRCUS PARADE, C. 1900. The circus comes to town with its carved and gilded wagons, bands, and animals. The building to the left, the Odd Fellows hall, is where M&M Sporting Goods is today, at the corner of Main Street and Town Square.

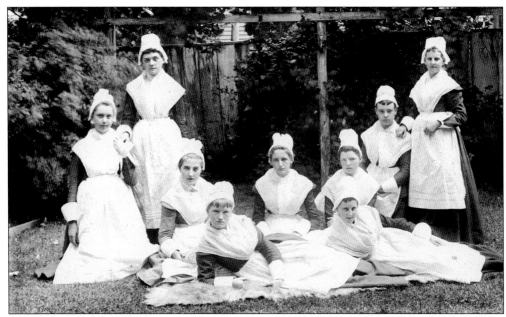

COSTUMED GIRLS, AUGUST 1, 1889. Taken in the backyard of Thomas Drew's house, at 9 North Street, this 1889 photograph captures the celebration of the completion of the Forefathers' Monument. The group—which included Mabel Dunham, Gertrude Avery, Emma Mayberry, Caroline Robbins, Jennie Robbins, and C. C. Holmes—had been stationed in nearby Shirley Square for the parade.

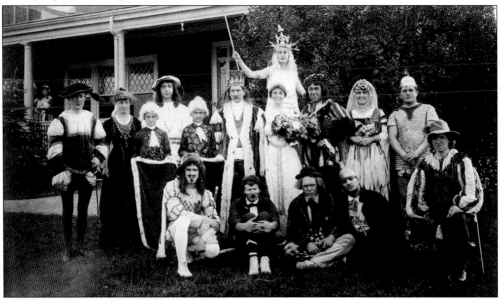

AT THE END OF THE RAINBOW, 1915. *At the End of the Rainbow* was performed as a benefit for the Ryder Home, the Plymouth Boys' Club, and the Jordan Hospital. Among the participants pictured here are the following: (first row) Elmer Gardner, Frank Gerrety, Alton Stevens, and William Resnick; (second row) Vincent Bockanan, Ruth Scully, Emery St. George, Will Snow, Mildred Holmes, Webster Dyer, Marcia Brown, and Paul Smithson; (third row) Rose Briggs (playing the Goddess of Dreams).

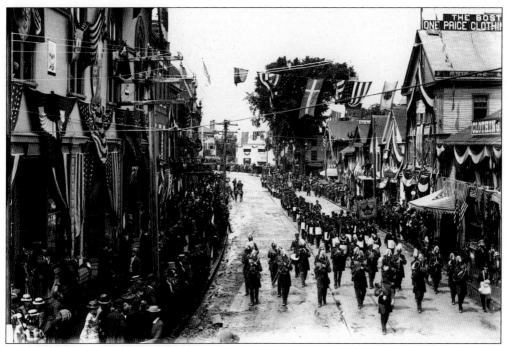

CELEBRATING THE COMPLETION OF THE FOREFATHERS' MONUMENT, AUGUST 1889. The parade route, which snaked through many Plymouth streets, passes south along Main Street. Compare this scene with the following view of a parade in the same location 50 years later.

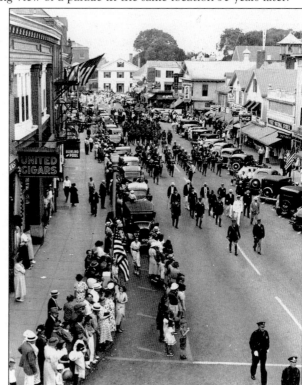

THE UNITED SPANISH WAR VETERANS PARADE, JUNE 18, 1938. The 39th encampment of the United Spanish War Veterans was attended by 1,400 people. Members of the Veterans of Foreign Wars (VFW) and AMVETS organizations also participated in the parade, seen here on Main Street.

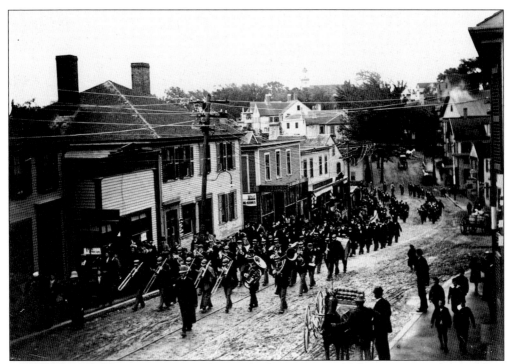

A PARADE ON MARKET STREET. In this southerly view toward Pleasant Street, the marchers are coming out of Sandwich Street. The buildings on the street were removed between 1940 and 1968 to create the parking lot near Tedeschi's and Dunkin' Donuts.

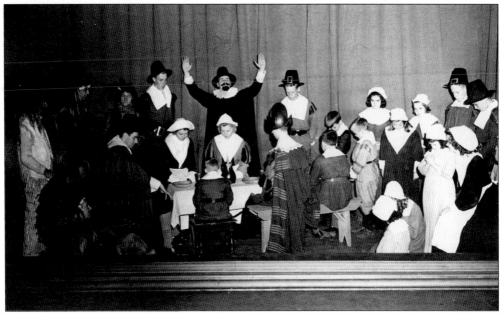

TABLEAUX AT MEMORIAL HALL, THANKSGIVING DAY, 1948. Depictions of scenes from Pilgrim history were first presented in 1921 and, from time to time through the 1950s, were held after the Thanksgiving Pilgrim Progress. Costumed personnel were assembled in position at Rose Briggs's direction and froze in place for a few minutes while the curtain was opened.

A FAMILY PICNIC AT BOOT POND, C. 1890. Picnics at Plymouth's ponds and beaches have been popular since before 1800. This family is enjoying the outdoors at the Burgess farm, which was a popular spot to rendezvous in summer months. The Burgess family owned the farm between Boot Pond and Great South Pond from 1801 to 1959.

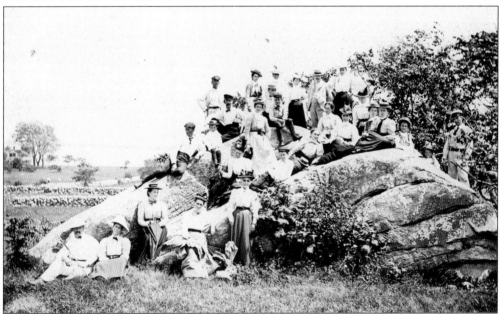

A PICNIC AT PULPIT ROCK, C. 1900. Clark's Island and its famous rock (in the lee of which the Pilgrims reputedly held their first sabbath at Plymouth, on December 10, 1620) was a favorite location for picnics. Previously called Election Rock, it was the site where Plymoutheans and Duxburyites customarily gathered on the old Election Day holiday (the third Wednesday in May) for special "election cake," lobsters, and lemonade.

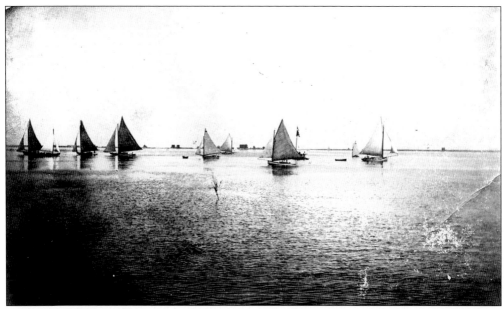

A CATBOAT RACE IN PLYMOUTH HARBOR, C. 1890. Because this image shows the Columbus Pavilion and several cottages on Plymouth Beach, we know that the photograph was taken before the Portland Gale of 1898.

THE FRESH POND CAMPGROUND, C. 1940. Managed by Seth E. Wall (shown with his wife, Martha, and two guests), the public campground at Fresh Pond in Manomet was established along with one at Nelson Street to give "auto-campers" a place to stay in Plymouth, for a charge of 50¢ per lot, per day or $3.50 per week. Fresh Pond campground was near what had been the end of the streetcar lines until 1928.

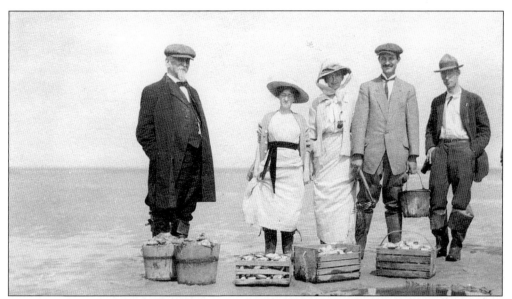

DIGGING CLAMS IN PLYMOUTH HARBOR, C. 1920. Clamming was both a popular activity and a commercial enterprise in Plymouth before an outbreak of typhoid fever caused the closure of the flats in 1925.

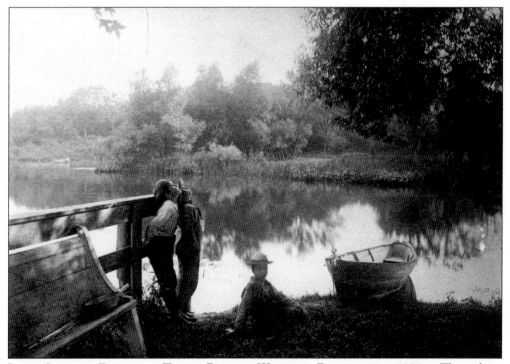

LAZY SUMMER DAYS ON TOWN BROOK, WILLARD PLACE, THE 1890S. Three boys contemplate the aimlessness of summer and the possibilities of a dory on Town Brook. The photograph was taken by H. C. Dunham.

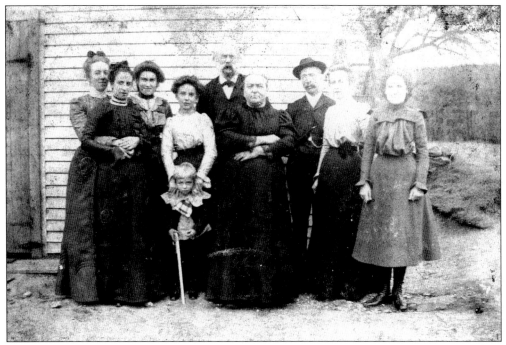

THE FERGUSON SISTERS AND FAMILY, THANKSGIVING 1900. Posing behind 67 Newfield Street are, from left to right, Mary F. Blossom, Annie Ferguson, Gertrude Ferguson, Agnes F. Raymond, Warren Raymond, Duncan Ferguson, Mary B. Ferguson, James Baker, Jennie F. Baker, and Beatrice Ferguson.

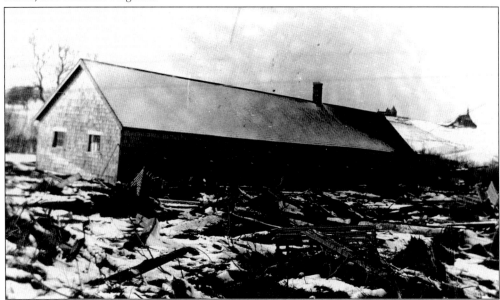

THE WADSWORTH BOWLING ALLEY, NOVEMBER 1898. Looking northeast toward the Hornblower estate, this view shows the Wadsworth Bowling Alley washed up on the shore of the Eel River Basin. During the Portland Gale of 1898, the building had been uprooted from its location on the east side of Warren Avenue, swept upstream, and deposited at this spot below C. M. Hauthaway's house.

A FIRE ON HIGH STREET, C. 1930. Looking northeast from Summer Street, this view shows the Ryder Home (the large house in the center), located at the corner of Russell and High Streets.

SAM B. HOLMES DRINKS FROM AUNT BECKY'S SPRING, C. 1895. This view looks south toward Plymouth Harbor. The spring of Aunt Becky (Rebecca Howes), located on Howes Lane, was famous for its clear, cold waters, although it could be reached only at low tide. Old Plymoutheans who had moved away came back just to get water from the spring. Today, the old barrel is gone, and the spring is polluted. All things must pass.

THE PLYMOUTH WATERFRONT, WATER STREET, DECEMBER 1953. This view looks north from a point in front of the Bluebird Restaurant (later known as the 1620). The old fish-processing plant set back from the road to the right later collapsed during a storm. That site is now occupied by the Lobster Hut. The low building behind the cars is the original Dearn and McGrath's (now the site of East Bay Grill).

PLYMOUTH'S HORSE-DRAWN HEARSE, NEAR BURIAL HILL, SCHOOL STREET, 1890. The accompaniment to one's permanent "leisure," the hearse was built c. 1820, when all burials were done by the sexton rather than by undertakers and funeral directors. Next to the hearse is the old bier on which the coffin was carried and supported as it stood next to the grave.